PUNK
AND
NEO-
TRIBAL
BODY ART

Folk Art and Artists Series
Michael Owen Jones
General Editor

Books in this series focus on
the work of informally
trained or self-taught artists
rooted in ethnic, racial, oc-
cupational, or regional tradi-
tions. Authors explore the
influence of artists' experi-
ences and aesthetic values
upon the art they create, the
process of creation, and the
cultural traditions that
served as inspiration or per-
sonal resource. The wide
range of art forms featured
in this series reveals the im-
portance of aesthetic ex-
pression in our daily lives
and gives striking testimony
to the richness and vitality of
art and tradition in the mod-
ern world.

PUNK AND NEO-TRIBAL BODY ART

Daniel Wojcik

University Press of Mississippi Jackson

Photo credits: James Wojcik, plates 8, 10, 13, 23, 24, 25, 31, 32, 43, 44; Knorr/Ricdon, photo courtesy of Omnibus Press, plate 1; Murray Bowles, plate 2; H. Closs, plate 3; Fincom Photography, plates 4, 28 (bottom); Neill Menneer, plate 5; Sally Greenhill, plates 6, 7, 21, 22, 26; Quartet Books, plate 9 and p. 18; Monica Breen, plates 11, 16, 17; Lynda Burdick, plates 12, 19, 20; Tom LeGoff, plates 14, 40; Mary Koroloff, plate 15; Jerry Rosen, plate 18; Heather Stewart, plates 27, 28 (top); Patrick Downes and Axel Koester, plate 29; Annie Sprinkle, plate 41; Todd Friedman, plate 42; Dennis Morris, photo courtesy Omnibus Press, p. 9; Robin Perine, p. 13; Jenny Lens, p. 15; Biz Eastlund, p. 14; unknown photographer, photo courtesy Omnibus Press, p. 19; all other photos by the author.

Library of Congress Cataloging-in-Publication Data
Wojcik, Daniel.
 Punk and neo-tribal body art / Daniel Wojcik.
 p. cm. — (Folk art and artists series)
 Includes bibliographical references.
 ISBN 0-87805-735-8 (cloth). — ISBN 0-87805-736-6 (paper)
 1. Body, Human—Social aspects. 2. Punk culture. 3. Body art. 4. Body piercing. 5. Tattooing.
I. Title. II. Series.
GT495.W65 1995 94-35350
391'.6—dc20 CIP

British Cataloging-in-Publication data available

CONTENTS

PUNK, the most notorious of recent youth movements, emerged in the mid-1970s and has persisted, in varying forms, to the present day. Characterized in the popular press as depraved, sinister, and "primitive," early punk subculture provoked widespread condemnation and instigated a sense of moral outrage. Twenty years later, punk is now being celebrated as a pivotal "cultural moment" that has influenced contemporary music, fashion, design, literature, film, and Western aesthetic trends overall (cf. Henry 1989:6; Marcus 1989; Savage 1991).

Initially a musically based movement, punk rock quickly developed into an oppositional subculture that expressed the estrangement and feelings of futurelessness experienced by youth in the late 1970s. As an aesthetic response to the inability of the larger society to meet the needs of individuals, punk constituted a form of resistance that provided a sense of identity, self-esteem, and community for alienated youth.

Punk body adornment appears to have evoked more analysis than that of any previous youth movement, yet it frequently has been depicted in stylized ways by the media and by academics. The creativity of punks often has been generalized, abstracted, or taken for granted, and the personal meanings, individual motivations, and specific aesthetic decisions of punks largely neglected in analyses of this subculture. In reality, the early punk movement constituted a dynamic expressive culture characterized by an exceptional degree of individual creativity. Punk never solidified into a set of immutable styles but has been continually reformulated aesthetically and ideologically, even to the point of rebelling against itself. Nor was punk ever completely co-opted, commercialized, and incorporated into mainstream society by the fashion and music industries. Instead, it was transformed into a diversity of musical and aesthetic movements that continue to have the potential to shock, outrage, or inspire. It was the astounding artfulness of punks that made the subculture subversive, and focusing on aesthetic aspects does not devalue the oppositional power of the movement but acknowledges the role of individual creativity in the development of transgressive subcultural styles.

After exploring the aesthetics and meanings of punk body adornment, this study surveys selected post-punk styles and then examines the body art of one individual, Perry Farrell. Deeply influenced by his experiences as a punk, Farrell has utilized forms of adornment inspired by non-Western body art and modification (tattooing, piercing, scarification) in an effort to create a uniquely individualistic aesthetic in response to the commercialization of punk style. When I met him in 1985, Farrell was unemployed and had just formed a band that he named Jane's

5

Addiction. He has since become one of the more significant figures in alternative music, being voted artist of the year by *Rolling Stone* and *Spin* magazines' music critics in 1991. He created the Lollapalooza tour in 1990, an annual cultural event that celebrates alternative music, and he currently is the lead singer for the band Porno for Pyros. The distinctive types of body adornment Farrell has chosen reflect his worldview, sense of aesthetics, interest in ritual, identification with tribal cultures, and the desire to "reinvent" himself. Farrell's aesthetic sensibilities and motivations for his body art illuminate the subversive and transformative appeal that permanent body alteration has for youth in contemporary Western societies.

I am grateful to Perry Farrell for allowing me to interview him and for providing the initial inspiration for this project in 1985. I am also indebted to the late Arnold Rubin, for whom a preliminary version of this study was written. My thanks to all of the following, for their opinions and assistance: Gayle Bigham, Murray Bowles, Monica Breen, Lynda Burdick, Robert Combs, Biz Eastlund, Casey Exton, Todd Friedman, Bevin Gardner, Henry Glah, Sally Greenhill, Robert Hardman, David Jones, Sarah Kerr, Tom LeGoff, Robin Perine, Michael Plavin, Scott Radke, Jerry Rosen, Mitchell Rosenbaum, Chris Schreiner, Sharon Sherman, Annie Sprinkle, Jim Ward, Brennan Washburn, and Jeffrey Wesolowski. I am especially indebted to Michael Owen Jones for his editorial advice and encouragement that helped bring this project to publication in this series. I am also grateful for the support provided by a Junior Professorship Development Award from the University of Oregon. Finally, I wish to thank Wieslawa, Konrad, brother James, and my parents, Gerald and Beatrice, for their interest and support.

IT WAS IN the summer of 1976 that punk rock made its debut in the popular media, primarily as the result of the scandalous antics of the British band the Sex Pistols. Much of the attention focused on their style of body adornment, their loud and "obnoxious" music, their "self-mutilation" (burning their arms with lighted cigarettes and scratching their faces with needles), and their obscene behavior (cursing on a nationally televised talk show and performing a "spitting and vomiting act" at Heathrow Airport). It was not long before a variety of other punk rock bands appeared, the members of which often had little or no prior musical training. Like the Sex Pistols, initial groups such as the Damned, Buzzcocks, the Clash, X-Ray Spex, and the Adverts, among others, emphasized a raw, amateur musical style and a self-effacing, "anti-rock star" approach. In small clubs and squalid spaces, these punk musicians screamed their condemnations of the status quo at ear-shattering decibel levels, implicating the pretentious conventions of corporate rock music in the process.

This early punk subculture was characterized by anticommercialism, antiromanticism, and a lack of distinction between musicians and fans. It also quickly became renowned for a style of adornment calculated to disturb and outrage: dyed hair, studded leather jackets, torn clothing, bondage wear, profaned religious articles, tattooing, clothing defiled with obscenities and swastikas, and safety pins piercing the nose, lips, and cheeks. Claiming to be anarchists and nihilists, punks offended as many people as they could: some were distressed by the punk use of sexually "deviant" paraphernalia; others were disturbed by the profanation of religious objects and the use of swastikas; activists were irritated because punks had no articulated political views; and arbiters of social propriety were disgusted by the emphasis on the sordid and obscene. Punk behavior and rhetoric, like that of previous youth subcultural groups, evoked a moral panic—a general horror and condemnation in the popular media that spread throughout society. Punks were demonized in the press and depicted in stereotypical ways as "folk devils" that threatened national morals and the social order (Hebdige 1979:157–58).

The punk subculture flourished in England because it captured the mood of the time and gave expression to many of the frustrations and concerns of urban youth, such as a high unemployment rate, dismal economic conditions, and a pervasive attitude of desperation and futility. The punk motto "no future," a summation of the sense of hopelessness inherent in the early punk ethos, comes from the Sex Pistols' song "God Save the Queen" (1977), which became an international punk anthem. In it, Johnny Rotten denounces the Queen's

PUNK AND NEO-TRIBAL BODY ART

Silver Jubilee celebrations, screaming to the alienated youth of England and Ireland: "God save the Queen, the fascist regime/They made you a moron, a potential H-bomb/God save the Queen, she ain't no human being/There is no future in England's dream/No future, no future, no future for you. . . ."

The Sex Pistols' condemnation of all authority, their disdain for societal conventions, and their pessimistic appraisal of the future immediately appealed to disaffected youth around the world, and punk quickly became a global phenomenon. Since early punk music was not generally promoted by the record industry or played on the radio, knowledge about the subculture was communicated primarily by word of mouth at record stores, nightclubs, and other meeting places, as well as through correspondences and hundreds of fanzines run by punks themselves, such as *Punk, Sniffin' Glue, Ripped and Torn, Rotten to the Core, Search and Destroy, Slash, Maximumrocknroll, Damage, World War III,* and *Flipside.* The grassroots character of punk is exemplified by the fact that even though "God Save the Queen" was banned on British radio and some stores refused to sell the record, the song climbed to the number two position on the music charts in England in July, 1977.

Punks not only formed their own bands and published their own fanzines but also established their own clubs and created low-budget, independent record labels. This reaction to the commercialism and elitism that characterized mainstream rock music in the 1970s allowed for the expression of ideas and art ignored or devalued by corporate record companies and other dominant cultural institutions. The do-it-yourself attitude of punk (condensed by punks to "DIY") is epitomized by the often-cited advice in the punk fanzine *Sniffin' Glue,* which has an illustration of three finger positions on the neck of a guitar and the caption, "Here's one chord, here's two more, now form your own band." This participatory, egalitarian ethos insists that every punk become actively creative as opposed to being a passive fan or consumer. The DIY aesthetic and low-budget approach arose partially because of an overall contempt for corporate rock music in the 1970s, with its strutting superstars, overly technical electronic music, and exorbitant concert ticket prices. In addition, most punk musicians simply did not have access to the expensive equipment and sophisticated recording systems controlled by record companies and reserved for established rock groups, so they created their own populist, musically based subculture.

Unlike British punk, American punk was not so much a working-class and bohemian response to economic depression and authoritarian ideology as it was a middle-class expression of alienation from and dis-

gust with mainstream values. Like their British counterparts, however, American punks often embraced a sense of societal disintegration and futurelessness. As a former punk from New York put it: "I liked that time of decay. There was a nihilism in the atmosphere, a longing to die. Part of the feeling of New York at that time was this longing for oblivion, that you were about to disintegrate, go the way of this bankrupt, crumbling city. Yet that was something almost mystically wonderful" (Savage 1991:133). The sentiment that society was collapsing and that there was no future pervaded American punk fanzines and lyrics. The well-known documentary film about punks in Los Angeles, *The Decline of Western Civilization,* by Penelope Spheeris, captures this sense of pessimism, epitomized by singer Darby Crash of the band the Germs, who was one of the first and most influential punk singers in Southern California. Crash performed in a state of drug- and alcohol-induced oblivion and eventually committed suicide. The destructive aspect of the punk movement became ritualized in the form of ceremonial violence, slam-dancing, drug and alcohol abuse, and other forms of actual or symbolic self-negation.

While feelings of despair and anomie have been expressed by members of numerous youth groups, many punks elevated the idea of personal and societal negation to an aesthetic. The names of var-

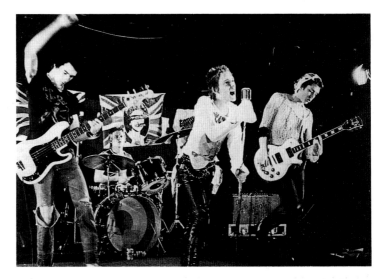

A Sex Pistols concert in June, 1977. From left to right: Sid Vicious, Paul Cook, Johnny Rotten, and Steve Jones, with a defaced image of the Queen of England as a backdrop.

ious punk bands illustrate this emphasis on destruction, futility, and decay: Damage; Damned; Dead Boys; Dead Kennedys; The Last; Living Abortions; Null and Void; Rotters; Stranglers; Suicidal Tendencies; U.K. Decay; Wasted Youth. The pseudonyms that punks often assumed emphasized the same themes, as well as self-effacement, parody, and the absurd: Johnny Rotten; Sid Vicious; Rat Scabies; Steve Havoc; Adam Bomb; Lorna Doom; Tequila Mockingbird; Bob Noxious; Jello Biafra; Phester Swollen; Alan Suicide.

Although punk ethos has been characterized as anarchistic and nihilistic (cf. Hebdige 1979; Marcus 1989; Nehring 1993), the frequent emphasis on doom and destruction—personal destruction, societal destruction, the destruction of all domi-

nant discourses—reveals the apocalyptic themes in punk. Consistently manifested in lyrics, fanzines, posters, manifestos, and behavior, this apocalyptic aesthetic was adopted by punks as a means of expressing their sense of estrangement, futility, and anarchistic impulses. While punks called for the destruction of a corrupt and bankrupt civilization, they generally had no articulated plans for the redemption of society. Yet the emphasis on destroying the status quo suggested that through negation, perhaps change was possible. When this ethos of destruction was combined with punks' do-it-yourself credo, it became the source of great creativity, inspiring the development of new styles of music, art, writing, and body adornment.

The apocalyptic legacy of punk can be traced to the influence of musicians such as Lou Reed and the Velvet Underground, Iggy Pop, Patti Smith, Richard Hell, the New York Dolls, and the Ramones. In addition to celebrating street life, urban decay, and social outcasts, these musicians frequently expressed pessimistic, fatalistic, and apocalyptic sentiments. The abusive and destructive aspects of these punk predecessors are exemplified by Iggy Pop, who cut himself with broken glass during performances, while he harassed and spit on his audiences. In his well-known song "Search and Destroy" (1973) he screams, "I'm the runaway son of the nuclear A-bomb/I am the world's forgotten boy/The

one who searches and destroys. . . ." This association of nuclear weapons and the threat of global annihilation with images of personal or societal destruction is a recurring theme in punk and proto-punk lyrics and artwork. Another source of punk doomsday imagery was reggae music, inspired by the millenarian vision of Rastafarianism, with its prophecies about the destruction of Babylon, identified as white colonialism, capitalism, and oppression in general. The music of David Bowie, who frequently addressed the theme of societal destruction and decay, also served as an inspiration for early punk apocalypticism.

Apocalyptic themes appealed to those punks who felt that contemporary society offered them no hope for the future. Envisioning their lives as "doomed," many punks adopted an apocalyptic ethos as the basis for symbolic action, a means of articulating their cultural pessimism and genuine sense of despair. This apocalyptic aesthetic was palpable in punk concerts, which often felt like symbolic enactments, or perhaps celebrations, of the collapse of all social order, a momentary, cathartic release from societal constraints. The music shook the walls of the ramshackle clubs and ruined auditoriums in which it was played; band members screamed, collapsed, spit on the audience, had seizures, lacerated their bodies, and threw themselves into the crowd. Fans leaped up on

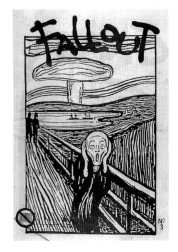

The depictions of mushroom clouds that were scattered throughout punk fanzines acquired an iconic quality, symbolizing the idea of no future and expressing nuclear apocalyptic fears, illustrated here by a modification of Edvard Munch's woodcut *The Scream*. From the cover of *Fallout* fanzine, Number 3 (illustration by Winston Smith).

the stage and did the same, hurling bottles and chairs, spitting their approval rather than applauding, and diving head first or somersaulting into the crowd (plate 2). On some occasions performances ended abruptly with band members in a comatose state; in other instances the unruly behavior of the audience ended such events; and, more than once, punk shows were stopped by police for their violation of any number of city ordinances.

An aesthetic of chaos and negation was also explicitly expressed in punk dances: "slam-dancing" involved running and throwing oneself into the other dancers, and the "pogo" was a denial of previous dance aesthetics, with individuals hopping up and down with their arms at their sides and crashing into one another. The editor of *Punk* magazine, John Holmstrom, who authored one of many initial punk manifestoes, states that a punk concert "is like an assault, you know. What the kids want is World War III, and we're giving it to them" (Selzer 1979:119). Despite an outward appearance of uncontrollable violence, there was an informal etiquette to early punk dance styles and other forms of punk ritual abuse. Although individuals slammed into each other, their actions usually were motivated more by a sense of camaraderie than anger. And while fights did occur in the "pit" in front of the stage, these were relatively rare; dancers knew how far to take this symbolic violence

without its becoming real. The sense of comradeship and the breakdown of the distinction between performers and fans at punk concerts was exemplified by the practice of stage diving, in which members of the audience or of the band would leap or somersault from an elevated stage into the crowd, where they would be caught and sometimes kept elevated or would be passed like a beach ball, from one side of the room to the other. Rather than engaging in mass violence or terrorism, punks expressed their alienation through communal rituals of symbolic negation and personal acts of self-abuse. Presenting themselves as symbols of a society in a state of crisis and disintegration, punks enacted their own drama of societal cataclysm, creating the overall impression that they were sacrificing their bodies on the altar of postmodern despair (plate 1).

Punk Body Art and Adornment

Punks, like previous postwar youth subcultures such as the teddy boys, the mods, the rockers, the skinheads, the beats, the zoot suiters, and the hippies, created a coherent and elaborate system of body adornment that expressed their estrangement from mainstream society and that horrified the general public. Having little access to dominant means of discourse, punks displayed their disaffiliation and their subcultural identity through such adornment, which was for them an accessible

and direct channel of communication. By manipulating the standard codes of adornment in socially objectionable ways, punks challenged the accepted categories of everyday dress and disrupted the codes and conventions of daily life. According to Dick Hebdige, punk style was subversive not only because it threatened established cultural boundaries, but more importantly because it undermined and exposed the ways in which such cultural classifications and hegemonic discourses are constructed (1979:117–27). Although the punk critique of society has been dismissed by some as naive, inarticulate, or merely a "ritual rebellion" through style, it constituted a critique nonetheless, a rejection of the status quo.

While punk explicitly threatened cultural boundaries and certain dominant ideologies, it implicitly challenged elitist notions of what art is and who may create art. In Western societies, art is generally associated with the "fine arts," often characterized as a distinctive class of objects usually lacking in utility (painting, drawing, sculpture, music) and created by only a few gifted individuals. Artful objects are supposedly distinguished by the aesthetic intent of the artist, as well as by their innovativeness and formal excellence, especially as these relate to notions of the "elegant" and "refined" (Jones 1987:81-95). In addition, the concept of "art" is usually associated with an institutionally sanctioned tradition of patrons and artists, masters and pupils, academic and studio training, collectors and dealers, museums and galleries, critics and historians.

Punk aesthetic behavior, in contrast to these elitist, class-based assumptions about what constitutes art, exists outside the sanctioned mainstream of the art world. In the same way that the unauthorized, masterful spray-painted images on subway cars in New York City are an example of contemporary folk art, punk body adornment is a grassroots form of aesthetic behavior, largely the creation of ordinary people who do not necessarily think of themselves as "artists." Punks developed the skills and mastered the techniques necessary to produce forms of adornment that expressed their street-level aesthetic and that reflected their collective experiences and values. The early styles of punk adornment were learned and communicated primarily in face-to-face interactions and informal contexts, and punks prided themselves on the handmade quality of their body art: they cut and colored their own hair, decorated their own jackets, tattooed and pierced themselves, and created ensembles of clothing and ornamentation from discarded fabrics and thrift store discoveries. While some initial punk style did reflect art school influences and imitate the clothing sold in Malcolm McLaren and Vivienne Westwood's shop called Sex, street punks quickly developed their own styles, and

certain standardized forms emerged that were conceived of as traditional by those who identified with the subculture.

In fact, punks borrowed from, reacted to, and created innovations around an assortment of previous musically based subcultural styles, such as glam rock (Gary Glitter, the New York Dolls, Marc Bolan and T. Rex, David Bowie, and Roxy Music), American proto-punk (Iggy Pop and the Stooges, the Ramones, Patti Smith, Television, the Velvet Underground), Jamaican ska and reggae, and skinhead. As Hebdige notes, "Punk reproduced the entire sartorial history of post-war working-class youth cultures in 'cut up' form, combining elements which had originally belonged to completely different epochs" (1979:26). Although the style was seemingly random and chaotic, punks were systematically choosing elements that were homologous with their values (which were the most degrading and shocking, for instance) and constructing these into a meaningful whole that expressed the ethos of the subculture. By appropriating and creatively recontextualizing images and objects associated with previous subcultural styles, punks generated new meanings for these forms and, through this process of bricolage, invented their own traditions reflecting their worldview.

While punks were masterful bricoleurs of previous subcultural styles, much of punk adornment was a reaction to the styles of their immediate precursors, the hippies, who were frequently mocked and identified as "the enemy." Feeling that hippies, despite their rebellious rhetoric, ultimately had contributed very little to the improvement of society, many punks accused them of being hypocrites who "sold out" and ushered in the "Me Generation," the conservative cultural climate of the 1970s and 1980s, and disco music, which punks abhorred. As a result, early punks created a style that was antithetical to the hippies' long hair and pony tails, beards, sideburns, nineteenth-century moustaches, moccasins, sandals, tie-dyed shirts, beads, long dresses, lack of makeup, earth tones, and peasant-inspired clothes. The punk ethos also inverted the hippie ideals of peace, love, romanticism, and rural utopianism by embracing nihilism, anger, symbolic violence, and urban decay. Unlike the hippies, punks offered no lofty solutions to societal ills. In their efforts to surpass hippie style (which was radical for its time), punks attempted to be more adventurous and consequently more aesthetically offensive than their hippie predecessors had been.

The most immediately recognizable aspect of initial punk adornment in Britain was brilliantly dyed and elaborately formed hairstyles. Unnatural hair colors such as pink, lime green, bright orange, blood red, deep purple, or combinations of several Day-Glo tones were used, and hair was

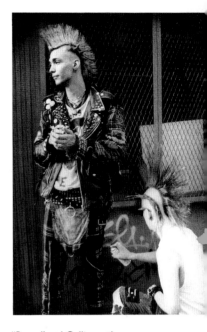

"Bones" and Collin on the warpath in New York City.

13

frequently styled into tufts, spikes, and other designs (plates 3, 4). Some punks dyed their hair jet black, an ever-popular color in the punk subculture because of its sinister connotations, while others bleached their hair with hydrogen peroxide. Both male and female punks frequently cut their hair short, cropped it in patches, or shaved their heads completely. Those who preferred longer hair created plumes or manes that seemed to defy gravity, giving the impression that a jolt of electricity had just passed through the bearer's body. Some punks created asymmetrical coiffures of varied lengths and designs; others wore feathery crowns that sometimes resembled halos or auras (plate 5). These hairstyles were held in place by an assortment of folk concoctions—egg whites, sugarwater, spray-on starch, Superglue, Vaseline, Ivory soap, lacquer, Elmer's glue—as well as by commercial gels and hair sprays such as Extra Super Hold Aqua Net (plate 6). The most renowned hairstyle associated with early punk is the "mohawk" or "Mohican," which involved shaving the sides of the head and leaving a vertical strip extending from the front to back (plates 7, 8). These brightly colored simulations of Mohican Indian hairstyles had connotations of youth on the "warpath" and evoked stereotyped notions of the "primitive," a designation that was used both to denigrate punk aesthetics and to label punk as a threat to Western civilization. Punk hair, with its angular styles and cacophony of colors, was made to appear as unnatural as possible, thus constituting an inversion of hippie hairstyles, which flowed naturally down the back or were tied in ponytails. While hippie hair communicated a "laid back" attitude, punk hair was a symbolic display of the aggression, intensity, and confrontational aesthetics of the subculture—a visual assault that threatened to invade the personal space of passersby.

In contrast to the often flamboyant, multicolored hair favored by early punks, their faces were frequently made up to look colorless and anemic. Both male and female punks often applied makeup in an exaggerated manner to give an impression of pallor and lifelessness. Pale and emaciated, resembling zombies or corpses, punk faces and physiques were often transformed into symbols of death or physical ailment, portraits of a diseased society that reflected the idea of futurelessness. The overall impression, as one former punk stated, was "kinda mealy looking—you know, kinda dead, like after World War III—the walking dead." Lips were often painted in colors associated with death— black, dark brown, grey-purple—or were heavily rouged, in imitation of the stereotypical prostitute. Layers of pancake makeup were applied and black eyeliner was used to create a deathly, ghoulish appearance. Occasionally eyebrows were shaved

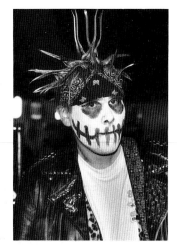

The skull-like effect created by punk facial painting expressed the ideas of futurelessness and death.

off, ornate designs were painted around the eyes, or fangs were drawn at corners of the mouth. Punk aesthetic was often defined in opposition to the world of fashion, venerating that which was traditionally considered unattractive, and treating so-called physical "flaws" as marks of distinction. By celebrating the uniqueness of individual styles that opposed prevailing ideas of good taste, punks implicitly critiqued dominant notions about beauty and fashion.

This antifashion aesthetic, which privileged the "flawed" and "rejected," is revealed by the punk preference for cheap clothing and fabrics with kitschy or bizarre designs. A hodgepodge of materials—plastic, plaid, tartan, lurex, nylon mesh, mock zebra, tiger, leopard skin, and even trash bags—was adopted, modified, and paraded on the streets (plate 9). Lace, leather, PVC, rubber, shiny fabrics, and army and school uniforms were also pervasive. Sometimes punks wore clothing inside out, thus displaying the construction of garments. Any style abandoned by the fashion industry as gaudy, cheap, or passé was embraced and exhibited. Ripped and soiled jeans, T-shirts, Doctor Marten boots, and steel-toed boots were popular, as were camouflage and military-style pants and shirts and anything else that contributed to an aggressive, terrorist, or guerilla combat look. Adorned in torn and tattered rags, punks looked as if they had just returned from a

fight, an automobile accident, or a battle-field. With their clothes shredded and held together by pins and strings, punks were literally falling apart at the seams, a reflection of their feelings of being abused and discarded by an unjust society.

In addition to an antifashion aesthetic, punk adornment frequently violated sexual taboos. One popular style of adornment among punk women was referred to as the "bad girl look," which consisted of wearing S & M gear, miniskirts (or long skirts slit to the hip), tight and revealing blouses, leather brassieres or corsets, garters, fishnet stockings, black lace gloves, stiletto-heeled shoes, and plenty of makeup. Other punk women created a style that was completely antithetical to the vamp/dominatrix look, cropping their hair, wearing steel-tipped boots, army pants, suspenders, uniforms, and T-shirts; still others juxtaposed elements from both of these styles (plates 10, 11). Whether they embraced "bad girl" style, or shaved their heads, wore Doc Martens, and got tattoos, punk women for the most part rejected established notions of feminine beauty, mocking sexist stereotypes through exaggeration, inversion, and parody. Themes of sexual ambiguity and gender confusion were explored by members of both sexes through their body adornment, and the asexual nature of much of punk style further upset conventional ideas about the display of masculinity and femininity (plate 12). Many punks

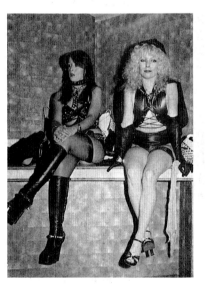

"Bad girls" adorned in leather gear, collars, chains, high heels, and boots.

shunned explicit demonstrations of romantic interest, and songs with conventional love themes were almost completely avoided by punk musicians, a reflection of the punk idea of having "no feelings" as well as a reaction to the narcissistic sexual posturing of the disco phenomenon and the hippie emphasis on "love" and "sexual liberation." This anti-romance ethos challenged traditional notions about female-male relations and, when combined with punks' egalitarian, do-it-yourself credo, gave women a significant presence within punk subculture. Even though early punk was a male-dominated movement like previous youth cultures, there were numerous women writers, editors, artists, managers, filmmakers, and musicians (e.g., Siouxsie and the Banshees, the Slits, Poly Styrene of X-Ray Spex, Lene Lovich, Exene Cervenka, Lydia Lunch, the Raincoats).

Among the garments favored by both female and male punks, the black leather jacket was probably the most universally popular. Punk jackets were often decorated with elaborate studded patterns, chains, zippers, hand-painted designs, buttons, badges, medallions, and decals (plates 3, 5). Associated with previous subcultures such as the rockers and bikers, the black leather jacket was embraced by punks as a familiar symbol of deviance. The use of studs and spikes, also inspired by biker and rocker styles, transformed punk jackets into dazzling forms of street armor weighing as much as fifteen pounds and offering protection against knife attacks and other types of assault. With their protruding metallic objects, punk jackets were also symbolically aggressive, a form of weaponry that suggested danger and violence. The punk use of studded and spiked wear also included collars, belts, gloves, and boots. The studs punks pressed into their leather accouterments were homologous to the piercings in their flesh, suggesting pain, torture, or perhaps sadomasochism (plate 14).

In addition to these meticulously adorned jackets, some punks wore denim jackets, which were not only cheaper than leather but easier to decorate (plates 5, 13). Other punks created denim-leather hybrid jackets to keep from destroying costly leather. These modified jackets were made by cutting off the sleeves of a denim jacket and placing the sleeveless denim vest over a leather jacket. Denim vests were drawn on with pens in a graffiti-like fashion or were painted, like leather jackets, with acrylics and enamels to display names or logos of bands, punk iconography (skulls, Grim Reapers, ghoulish caricatures, crucifixes), or slogans and symbols (a swastika, the word "anarchy" or its symbol, the letter A within a circle). Like their comrades in England who mocked symbols of Britishness, American punks often decorated themselves with anti-American slogans and derisive imagery that ridiculed societal institutions as well as cherished

ideas and icons (the government, President Reagan, organized religion, capitalism, the flag), thus exposing the hypocrisy and injustice that they experienced and identified in their daily lives (plate 15).

Punks also addressed those forbidden behaviors and tabooed words and topics usually reserved for discussion on restroom walls, painting and drawing indecencies on their clothes or bodies (the words "fuck," "death," and "hate" were particular favorites). Covered in obscenities and defiled with references to "perverse" sexuality or bodily secretions, punks transformed their bodies into a form of ambulatory latrinalia, the symbolic equivalent to defecating in public. Some punks embraced cliched evil images, drawing upon the kinds of stereotyped notions of devil worship and satanic imagery that never lose their potential to disturb. No tabooed topic was sacred, and punks realized and revelled in the power of obscene language and symbolic desecration.

In particular, representations of death pervaded early punk subculture and frequently appeared on punk jackets and clothing. This display of grisly and deathly images explicitly violated the cultural taboo against the direct confrontation and discourse about death that exists in the United States and Britain. The image of a skull with spiked hair or a mohawk, grinning or dancing, became a punk icon, an ever-present reminder of death's ultimate triumph over all, regardless of class or status. Punks not only adorned themselves with such images, but their personas and behaviors often embodied the idea of death in various ways: a pale and lifeless appearance, the overt painting of the face to resemble a skull, the frenetic slam-dances of death at punk nightclubs.

Tattooing was another widely embraced form of adornment that transgressed conventional notions about the proper appearance of the body. Although believed to be the oldest and most pervasive type of permanent body modification, tattooing in Western culture until recently has been associated with deviance and marginality—the indelible badge of bikers, sailors, prisoners, prostitutes, savages, and circus freaks. Punk tattoos, inspired by the aesthetics of bikers and rockers, as well as by the teddy boys and rockabillies, served to stigmatize the bearer as someone existing outside of societal conventions. Unlike other forms of punk ornamentation which were temporary, however, tattooing signified one's commitment and allegiance to punk identity (plates 16, 17).

Initially, most punks were wary of established tattoo artists, whom they dismissed as too old, too mainstream, too expensive, or too conservative to administer the designs they desired. Therefore, many punks tattooed themselves or were tattooed by friends, the result being somewhat crude designs that reflected the punk

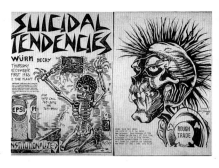

Skull imagery pervaded the handbills—cheap, throwaway photocopied fliers—that punks created to promote their music. The handbill on the left is for the Los Angeles band Suicidal Tendencies and refers to their song "Institutionalized" (art by RXCX). The skull with the mohawk on the right is from an advertisement for the important independent punk record company Rough Trade, a shop and mail-order label located in London that enabled punks to produce and sell low-budget albums and that provided other types of support as well (art by Uncl' Pushead).

do-it-yourself ethos and its emphasis on an amateur, unpolished aesthetic. Later, as some punks became trained in the art of tattooing, punk tattoos became more sophisticated, with the designs more complex and diversified. Tribal designs, for example, appealed to some punks who valued the bold features, unique patterns, and exotic connotations of ancient tattoo imagery from Borneo, Polynesia, and Micronesia.

Punks borrowed motifs from Western tattoo tradition, but they were also innovative in developing their own unique designs that expressed their personal and subcultural aesthetics. Unlike traditional Oriental-inspired tattooing, which involves covering an entire area of the body, such as the arm, with one design, punks seemed to prefer a pastiche aesthetic that resulted in a composite of designs (plate 18). Like the decorations on punk jackets, early punk tattoos frequently dealt with the subject of human mortality. Skulls, crossbones, figures of death, and macabre imagery were common (grinning skulls with mohawks or spikes were ubiquitous). Spiders, spider webs, bats, snakes, crosses, and punk symbols for anarchy were popular as well (plates 19, 20). Other motifs included names of punk bands or a particular style of music, song lyrics, artwork from record covers and fanzines, political slogans, and images of favorite punk performers. After Sid Vicious of the Sex Pistols died of a heroin overdose, for instance, a number of his fans had his portrait tattooed on their bodies. Some males got tattoos of nude or scantily clad punk women with mohawks, a variation on a traditionally popular design among men (plate 18). Punk women were also tattooed, an even more substantial violation of accepted codes of adornment than tattooing among men. Tattooed women were relatively uncommon in the 1970s, and a woman with a visible tattoo was generally stigmatized as deviant or promiscuous. Although some tattooed female punks embraced macabre imagery, many seemed less interested in grisly and aggressive designs, preferring symbols of their favorite bands, "gloomy" designs (i.e., bats, spider webs), floral motifs (often in black), or personal insignias (plates 19, 20).

The use of body piercing, or what was referred to as "mutilation" by the mass media, had particularly powerful symbolic connotations (deviance, pain, masochism, self-destruction) and seemed to disturb non-punks more than all the other styles—hair, leather jackets, clothing, and tattoos—combined. Safety pins or razor blades dangling from ears were common, as were skeletons, crucifixes, swastikas, the hammer and sickle, iron cross, skulls, and other incongruous symbols or shocking objects (plate 21). Rings, safety pins, or studs worn in the lip, cheek, nose, or eyebrow proved even more unsettling (plates

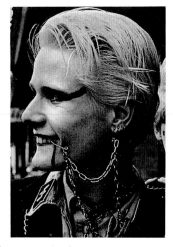

Chains attached by safety pins in the cheek and ear were an especially shocking form of early punk adornment that suggested bondage, pain, and defacement.

22, 23, 24, 25). Occasionally objects such as bones were displayed as nose or ear ornaments, but mass-produced commodities were more frequently used. Punks literally skewered and lacerated themselves with the mundane debris of daily life. The stereotyped image of a punk with a safety pin through a cheek became an icon of deviant youth, a media symbol of the punk folk devil that intensified a sense of moral panic in the wider population.

Punks also decorated themselves with objects from unsanitary and profane contexts, yet another form of symbolic pollution. Tampons were dangled from an ear or a coat, and clothing was defiled with written obscenities, artificial blood, and dirt. Undergarments and lingerie were worn over clothing, and razor blades, paper clips, toilet chains, bullet casings, light bulbs, safety pins, false teeth, and various found objects were displayed as well (plate 22). Punks used trash and discarded paraphernalia as adornments to symbolize their sense of rejection and their feelings about being society's garbage. The idea of the degraded, the meaningless, and the forbidden was consistently exposed and glorified, and these symbolic transgressions through adornment stigmatized the wearers as defiled and dangerous.

Forbidden and deviant connotations were especially evoked by the punk use of the entire repertoire of bondage wear and sexual fetishism. Leashes, thongs, tethers, chains, belts, straps, bodices, masks, and assorted leather and rubber gear were taken out of the context of the X-rated film, the adult book store, or the bedroom and incorporated into punk style (plates 19, 20). This flaunting of sex shop and sadomasochistic accessories served primarily to shock, threaten, or expose culturally constructed ideas about "deviancy" rather than to entice. Trench coats and soiled raincoats were also a popular article of dress, with their dirty-old-man and "flasher" connotations. This use of adornment with implications of perversion occasionally produced an incongruous comic effect. Punks who wore bondage pants, the legs of which were connected by chains, strips of leather, or canvas, waddled down the street, not only suggesting sexual deviance but also the slapstick, shuffling amble of Charlie Chaplin or perhaps a toddler taking its first steps. Such bondage wear, as well as the popular spiked dog collars, leashes, bicycle chains, and padlocks worn around the neck, symbolized enslavement and helplessness, and sometimes imbued the bearer with an almost martyr-like quality (plate 1).

In contrast to the display of objects and clothing associated with depraved contexts, symbols of the sacred were also used by punks, usually in an unconventional or sacrilegious manner. Religious items were exhibited in nonstandard ways, such as a crucifix being pinned to a jacket or

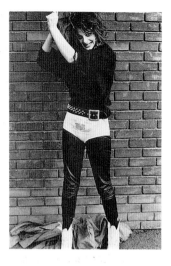

Arri Up, from the all-female British band, the Slits, wearing underwear over leather pants imprinted with an emblem that commemorates the Queen's Silver Jubilee celebrations.

19

hanging from an ear. Rosaries, often several at a time, were worn over clothes, and crosses appeared upside-down. By displaying such objects out of their normal surroundings, punks inverted their meanings, transforming them into symbols that offended and disturbed.

Perhaps the most threatening object used by punks was the swastika, which was employed to horrify rather than to indicate an actual interest in Nazism, since most early punks were antifascist. Punks created a new meaning for the swastika by recontextualizing it and transforming it into a sign of provocation and a symbol of current totalitarianism at home. By wearing swastika earrings and arm bands or painting swastikas on their clothes or faces, punks also stigmatized themselves as evil and adversarial (plate 9). The shock value of punk was achieved not only by this use of offensive items, but by the juxtaposition of incongruous symbols, such as a crucifix and a swastika hanging side by side. Such displays created alternative meanings for these objects, which were exposed as being devoid of any intrinsic significance and which were used to confuse and subvert the ideologies that they had traditionally symbolized.

The Commercialization of Punk Aesthetics

Despite the subversive aesthetics of punk body adornment, certain aspects of the style were promptly appropriated by the fashion industry and made palatable for mainstream consumption, once punks' symbolic vocabulary had become somewhat familiar. Roughly one year after the appearance of punk style, an article in *Newsweek* announced, "Both Saks Fifth Avenue and Bonwit Teller carry gold safety pins at prices up to $100, and noted British designer Zandra Rhodes recently created a collection of gowns for Bloomingdale's that incorporates stylized rips and glitter-studded safety pins—at $345 to $1,150 a gown" (June 20, 1977:80). Once the industry of haute couture commodified punk adornment for elite and mass consumption, the outward forms of punk aesthetic lost much of their potential to disturb and infuriate.

The threat posed by punk behavior was also decreased by innocuous portrayals of punks in the media and elsewhere. Those who had been initially stigmatized as deviant folk devils now appeared in endearing depictions of punk life—punks with their proud mothers and fathers, punks with their babies, and punk rags-to-riches stories (plate 26). Tourist postcards and media images of punks in romantic embraces rendered the repugnant punk persona less disturbing by offering the assurance that despite their menacing appearances, punks were capable of tender emotions.

Jokes caricaturing punks further dimin-

ished the shock value of punk aesthetics. For instance: "A punk rocker goes into a bar, and he's fully decked out—rainbow-colored mohawk, ripped clothes, leather jacket—and he sits down next to a very conventional-looking guy who gives him a real strong stare—a glare—and this guy stares at the punk for a long time. So the punk says, 'Hey look, man, didn't you ever do anything crazy when you were young?' And the guy says, 'Yes, when I was eighteen, I screwed a peacock, and for a minute there I thought you might be my son.'" Another example renders punk adornment completely ludicrous:

Q: Why did the chicken cross the road?
A: To get to the other side.
Q: How did the punk rocker cross the road?
A: Stapled to a chicken.

In these ways punk style was trivialized and mocked, or conversely "celebrated" for its aesthetic merit on postcards and in popular publications. In either case, the profound disaffiliation and rage that the original punks felt was disregarded or ridiculed. Punk body adornment and music, divorced from its authentic anarchistic and apocalyptic ethos, was exploited as the "the newest fad," just another youthful trend welcomed by corporate record companies and entrepreneurial fashion designers (plates 27, 28, 29).

The trivialization and commercialization of punk—its becoming an acknowledged musical and fashion genre—prompted the claim that "punk was dead." Theorists of subcultures made similar assertions, noting that while punk style had initially challenged dominant ideas and meanings, in the end capitalist culture had devoured punks' dissident energies and styles, commodifying, simplifying, and diversifying them for the market place (Hebdige 1979:92-99). According to this interpretation, punk, like previous youth subcultures, had offered a momentary resistance to the status quo but ultimately was assimilated into the dominant society, serving to reinvigorate the fashion and music industries.

Post-Punk Body Adornment

Despite commercialization and co-optation, punk aesthetics and ideology were never completely incorporated into mainstream society. Stereotypical depictions of punks continue to evoke connotations of deviance and are still used to represent the embodiment of dangerous youth (plate 30). The punk subculture did not "die" immediately after its inception (a death that has been debated and refuted periodically in punk fanzines for nearly two decades). There are still many individuals who consider themselves punks, "post-punks," or "alternatives" (as well as many who refuse such labels altogether), and who continue to be inspired by the legacy of early punk in some way (plates 8, 10, 11,

21

13, 16, 23, 24, 25, 31, 32). The label "post-punk," although rejected by some and considered too broad by others, has been used loosely to refer to later incarnations of punk and the profusion of punk-inspired music and style. Just as punk never became a monolithic subculture but represented a diversity of musical and artistic styles, post-punk consists of an assortment of subcultural identities, musical genres, and forms of adornment and includes factions known as new wave, gloom, gothic, gloom-glam, no wave, thrash, industrial, hardcore, psychedelic-punk, "Oi," peace-punk, positive punk, anarchist punk, straight edge, neo-skinhead, speed metal, new romantics, two-tone, neo-rockabilly, grunge, and riot grrrls, among others. While some of these post-punk movements have closely adhered to the conventions of early punk, others have departed stylistically, having been influenced in some way by the original punk ethos.

Often this identification with initial punk style and worldview is no longer expressed in terms of the more spectacular forms of early punk body adornment. In fact, American punks initially preferred torn T-shirts, ripped jeans, and leather jackets to the more elaborate styles flaunted in England. Contemporary punks, as well as many post-punks (thrash, hardcore, or political punk, for instance) frequently express a similar disdain for the flamboyant aspects of early punk style. Specific forms of dress might include T-shirts or plaid shirts, jeans, short or long hair (not necessarily dyed or noticeably styled), leather jackets, wristbands, boots, bandannas, baggy pants, baseball caps, and perhaps some tattooing or body piercing. As one individual who continues to identify with punk ethos recently stated to me, "Punk—or post-punk—is an attitude, not a dress style."

Of the musical styles that immediately followed punk, the most popular was "new wave," a broad category that refers to a less offensive, decontaminated version of punk that was associated with bands such as the B-52s, Blondie, the Jam, Elvis Costello, the Talking Heads, the Boomtown Rats, the Police, the Pretenders, and the Go-Gos, among others. Because new wave was technically polished, melodic, and somewhat more romantically inclined, it was more accessible and marketable than punk. New wave body adornment consisted of a diluted punk style and an eclectic combination of dated, mainstream styles of fashion, resulting in an odd pastiche of normal-looking attire, and including items like wing-tipped shoes, thin ties worn loosely, horned-rim glasses, mock leopard and zebra skin, leather jackets, old suits, sunglasses of the types worn in the 1950s and 1960s, short tight skirts, high heels, go-go boots, short hair among men,

hairstyles from the 1950s and 1960s among women, and any black accessory.

Probably the most visually spectacular post-punk phenomenon in terms of body adornment is the "gothic" subculture (referred to in its various stages as gloom-rock, horror-rock, and death-rock). With its origins in the "gloomy" ethos conveyed by groups such as Siouxsie and the Banshees, Joy Division, and Bauhaus, as well as by the various personas of David Bowie, gothic subculture emerged suddenly in the early 1980s with the appearance of bands such as Alien Sex Fiend, Sex Gang Children, the Sisters of Mercy, and the Fields of Nephilim, who performed at the Bat Cave, a London club. Gothic style reflects a fascination with the macabre, the gruesome, and the supernatural, melding a preoccupation with Victorian romanticism, the iconography of horror films, and representations of a "fiendish" sexuality. Many goths embraced the deathly and nihilistic themes of punk, glamorizing these by developing them into an aesthetic ideal. Rather than shredding their clothes and adorning themselves in debris like early punks, goths created elaborate, colorless costumes that expressed their fetishization of the sinister and morbid: clothing that is almost exclusively black; hair dyed jet black or sometimes red, shaved into manes, teased into feathery plumes, or made to appear uncombed and disheveled; eyes heavily shadowed with mascara and lips painted black, grey, brown, or red; fingernails painted with the same colors; pancake makeup used to render faces deathly white so that individuals resemble corpses, ghouls, Dracula, and Vampira. Tights and stretch pants are often worn with billowy shirts and blouses made of velvet, silk, or satin, and an androgynous appearance is common among both men and women. Black fishnet and lace are popular, as are leather jackets, black gloves, sexual fetishistic paraphernalia, motorcycle boots, high heels, shoes with pointy toes, and occasionally cloaks and capes. Tattoo motifs and items of ornamentation include skeletons, vampires, bats, spiders, fairies, fantasy creatures, and symbols associated with religion, the supernatural, and the occult.

Another musically based subculture that has been influenced by punk aesthetics is the "industrial" movement, associated with bands such as Ministry, Nine Inch Nails, Skinny Puppy, KMFDM, and Psychic TV, and earlier groups such as Throbbing Gristle, Einsturzende Neubaten, and Depeche Mode. While at times danceable, industrial music is often a thrashing barrage of dissonant noise, characteristically abrasive and morose. The industrial movement expands on the pessimistic and apocalyptic themes in punk, as well as on the gloomy, "sinister" aspects of gothic. Often it elabo-

rates on the punk preoccupation with culturally taboo subjects, exhibiting a fascination with sexual perversion, torture, fascism, mass murderers, the occult, and other subjects that continue to shock and horrify most people. The forms of body adornment associated with industrial subculture vary but often include dark clothing, heavy boots, leather wear, punk-inspired hairstyles, shaved heads or long hair, and clothes that create an androgynous appearance. Tattooing and body piercing are especially pervasive.

Another immediately recognizable youth subcultural style influenced by punk is "neo-skinhead," initially associated with British bands such as Sham 69, Angelic Upstarts, Cockney Rejects, Cocksparrer, the 4-Skins, and the "Oi" movement (taken from the British working-class greeting, "Oi, you!"). While skinhead has existed in England since the late 1960s, the neo-skinhead revival was largely inspired by punk. Although often stereotyped as racists and fascists, most neo-skinheads originally shared the anarchistic ethos of punk, and the majority initially appeared to be apolitical or explicitly antiracist (e.g., SHARP, Skinheads Against Racial Prejudice). Neo-skinhead style exaggerated elements of early skinhead body adornment, expressing proletariat themes and a desire to re-create an idealized community associated with the past by elevating the stereotype of the clean-cut, working-class male to an aesthetic.

More overtly aggressive, gang-oriented, chauvinistic, and self-consciously machismo than other post-punk factions, neo-skinheads expressed a disdain for the sexual ambiguity and arty, flamboyant aspects of glam, gothic, and punk.

The principal emblem of skinhead identity is a shaved head or closely cropped hair, a symbol of toughness and surliness. Popular forms of adornment among both males and females include pressed work trousers, Levi's, suspenders, T-shirts, crombies, Pendletons, parkas, porkpie hats, denim jackets, V-neck sweaters, flight jackets, windbreakers, and polished, steel-toed work boots. Male skinheads rarely grow facial hair, although some have long sideburns. Skinhead women often crop their hair short and may also blur gender differences by wearing "masculine" forms of adornment. Other women may leave feathered fringes around their faces and down the backs of their necks. Fishnet tights, miniskirts, and long, two-tone jackets are popular among women; makeup sometimes consists of black mascara and pale-colored lipstick. The use of tattooing is common among skinheads and body piercing has become increasingly pervasive.

The most commercially successful post-punk phenomenon is "grunge," initially associated with the independent Sub Pop record label in Seattle, which promoted raw, "alternative" music in the late 1980s. The band Nirvana is credited with estab-

lishing the grunge movement, after their punk-inspired album *Nevermind,* a paean to youth alienation and boredom, sold 10 million copies worldwide and knocked Michael Jackson off the top of the popular music charts. Nirvana's success put alternative rock, previously relegated to the periphery of pop music because of its unpolished, amateur style, into the commercial mainstream, paving the way for bands such as Pearl Jam, Alice in Chains, Soundgarden, Smashing Pumpkins, and Mudhoney, among many others.

Grunge body adornment is characterized by an unkempt, shabby appearance inspired by a thrift store aesthetic. Consisting of a mishmash of ragged, dated styles of clothing, grunge adornment appears to express a complete disregard for fashion, giving the impression that one is "not trying" to have a style but simply wearing the first, and cheapest, items found in a thrift store bin. Utilitarian and austere, grunge adornment includes threadbare, plaid flannel and tattered lumberjack shirts (sometimes with the sleeves torn off), worn Levi's with blown-out knees, granny dresses, ratty cardigans and moth-eaten sweaters, Doc Martens or other heavy work boots, unkempt hair, ski caps and knit beanies, cheap, generic tennis shoes, and T-shirts, occasionally vintage ones, with kitschy logos or odd, iron-on images from the past. Melding punk angst and a 1970s post-hippie impoverished look, grunge reflects the post-baby boom apathy of the 1990s, induced by the feeling that the grunge generation (also dubbed "Generation X" and "slackers") has not only inherited the world's problems from thriving baby boomers and affluent ex-hippies but has been condemned by social and economic conditions to a future of dead-end jobs, boredom, and an inescapable downward mobility. This sense of nihilism, despondency, and futureless-ness is explicitly reflected in the shoddy, tattered, "why try?" look of grunge style.

A related post-punk phenomenon that emerged in 1991 is "riot grrrl" (also referred to as "baby fem"), a movement comprising punk women in their teens and mid-twenties. First associated with all-female alternative bands such as Bikini Kill, Bratmobile, and Seven Year Bitch, and inspired by Kim Gordon of Sonic Youth and Courtney Love of Hole, riot grrrls combine neo-feminist attitudes with the anger of punk and a modified grunge aesthetic. Dissatisfied with the male-dominated aspects of the contemporary punk subculture, riot grrrls created their own grassroots movement, a punk support group for women only that addresses matters of sexism, sexuality, rape, abortion, politics, mainstream ideas about beauty and the body, and the experiences of young women in general (Taylor 1993:2).

Riot grrrl style varies considerably, although there seems to be an affinity for

little-girl dresses or a schoolgirl look, combined with Doc Marten boots, fishnet stockings, miniskirts, or tight T-shirts. Granny dresses, cardigans, cheap tennis shoes, and other aspects of grunge style are also popular. Makeup may be used in an exaggerated manner, with lips thickly painted in deep red and eyes and other areas heavily made up in ways that are contrary to conventional cosmetic usage. By juxtaposing baby-doll dresses with work boots and an overtly sexual style, riot grrrls parody stereotypes of women that portray them as innocent, dainty, and timid. Some riot grrrls regard the use of an explicitly sexual style as empowering, a means of expressing the freedom they feel to dress in any way that they desire. This style also inverts and mocks dominant ideas about femininity in a manner similar to the "bad girl look" employed by earlier punk women. The confrontational aspect of riot grrrl is also illustrated by the words or slogans they occasionally write on their bodies with lipstick or magic markers (e.g., "SLUT," "BITCH," "RAPE," or "QUEER"), a form of body art that transforms these derisive words into "self-validating labels" that visually assault perceived oppressors (Taylor 1993:1). Their choice of the word "girl" as a defining label, with its normally sexist, trivializing connotations and implications of immaturity, demonstrates a similar type of appropriation. Pronounced with a growl, "grrrl" becomes a word of empowerment, in the same way that "queer" has been reclaimed by lesbians, gays, and bisexuals and is now used in a confrontational and emancipatory way as an expression of identity.

Perry Farrell's Neo-Tribalism

In addition to these and various other forms of post-punk adornment adopted by youth to express affiliation with an identifiable subculture, there are many post-punks who have created individualistic forms of adornment that depart from early punk and these broader post-punk styles. One such person is Perry Farrell, who exemplified this approach to body adornment when I met him in the fall of 1985.

Since that time, this informally taught artist and musician, who once lived in the streets of Los Angeles, has become one of the more influential and controversial figures in alternative music. As noted earlier, Farrell was voted artist of the year in 1991 by the music critics for *Rolling Stone* and *Spin* magazines. He has been recognized for his "uncompromising artistic integrity," praised for returning rock-and-roll to its underground roots, and credited with initiating the interest among major record labels in alternative music (Arnold 1993:134; Gold 1994:42). In 1990, Farrell created and organized the Lollapalooza tour, a "touring Woodstock" with exotic foods and circus-like sideshows, which is both an arena for alternative music and a

cultural event that attempts to raise public awareness about political, environmental, and human rights issues. Lollapalooza has been condemned by some mainstream media for its angry, "brutal," "jungle" ethos, illustrating the continued oppositional threat that youth subcultural behavior may pose to dominant society (cf. Leland 1991).

When I met Farrell in 1985 he was jobless and had just quit his previous band, Psi-Com (plate 33). He had recently formed a new band called Jane's Addiction, in which he was the lead singer and lyricist. At that time he embraced much of the original aesthetic and ethos of punk, but he no longer identified himself as "punk" and he rejected the label "post-punk." This departure from punk was exemplified by a unique style of body adornment. He had altered his appearance with tattoos, multiple piercings of both ears, piercing of the nasal septum, scarification, dreadlocks, and a distinctive clothing style. His motivations for acquiring these forms of adornment are diverse and complex, involving considerable commitment and encompassing his beliefs and sense of aesthetics.

Farrell was born Simon Bernstein in 1959, in Queens, New York. When he was four years old, his mother killed herself, an event that he had rarely discussed until recently: "She died of a broken heart, that's what drove her to suicide . . . and we kids are all heartbroken. We missed out on a mother. . . . Nothing came of it, so I came to the conclusion: Why throw your life away? Why throw yourself on the pile? Why throw your life into the flame? Your life is the one thing you have to fight with, why give it up? I have never found anything big enough to give up my life to, especially if it was something that I hated or bothered me. The last thing I would give is my life. If I don't like something, I don't give it my time. I won't give it my life" (Allen 1994:42). His mother's death was the first of several traumatic experiences that have influenced his approach to life and art.

After his mother's suicide, his family moved to Woodmere, Long Island, and then later to Miami, where Farrell went to high school. He found school for the most part to be tedious and unchallenging, and he preferred going surfing to attending classes. He left Miami and moved to California in the late 1970s to enroll in MiraCosta Community College in Oceanside. During this time he worked in a vitamin factory, but the chemicals caused his eyelashes and eyebrows to fall out. He dropped out of school because of the emotional strain (Handelman 1991:70). Later he worked as a waiter and a self-taught, freelance illustrator. For a two-month period he lived in the streets of Los Angeles. "I literally lived, I lived in a car. Anywhere I could. I lived with my girlfriend in the car, which was a real trip! Every

morning, I'd get up and take a suit and tie out of the trunk, flap it out, you know, leave it on the hood, get it warm, so it would loosen the wrinkles. . . . And then I'd go down lookin' for a job as a bus boy or a waiter. . . . I didn't have any money—I just had a car! It's the car I have now—that's why I can't sell it. I owe it something." For a while he worked delivering liquor to such places as a private club in Newport Beach, where he was offered a job as a "dancer" who would perform in "tight swimming trunks." Later at the same club he worked as an impersonator, lip-syncing the sounds of Frank Sinatra, David Bowie, and Mick Jagger, sometimes dressed in drag. Eventually he quit his job at the club and purchased a PA and headphones in order to pursue singing (Handelman 1991:70).

Farrell first became involved in punk in 1979, and he continues to identify with much of the character and spirit of early punk. As he recently stated, "Punk rock was exciting because you would get your ass kicked for looking like a punk. Punks were atrocious. They spit on people. They created mayhem. Now you just throw on a plaid—*that's* not style. Grunge just means lack of creativity. . . . I'd rather see a bad haircut. I hate saying this, because it's probably the same thing Frank Sinatra fans say now, but I'm looking for excitement" (Gold 1994:44). When I asked him why he became a punk, he replied, "For me, it was

a way to express how fucked-up everything is. Everything is so upsetting; there's not much you can do really, but it was one way for me to rebel." When he lived in Hollywood, he associated with punk bands such as X, Social Distortion, Savage Republic, and the Minutemen, and admired singers such as Lou Reed, Ian Curtis, and especially Iggy Pop, all of whom are renowned for their uncompromising approach to music and life. Farrell stated, however, that punk stood for more than raw honesty and true grit: its anti-big business ethos was important, it encouraged people to "think for themselves," and its "do-it-yourself" attitude was ultimately empowering. To be a punk, he said, "took a lot a guts, and [punks] took a lot of abuse . . . I see a kid with a mohawk and I respect him. It's not easy. Yeah, you take a lotta shit. . . . I had the shit kicked outta me because I looked that way."

During this period he changed his name, a customary practice among punks, that afforded a symbolic escape from previous identities and a conventional existence. He renamed himself Perry Farrell, a play on the word "peripheral," adopting his brother's first name, "Farrell," as his last. Like other punk pseudonyms and adopted personas that distilled some aspect of punk worldview—decay, aggression, negation—or a personal creed, Farrell's name embodies his sense of social marginality and his fascination with cultural

boundaries. The name Farrell also evokes the "feral child" and "wild man" images of folklore, with their myriad connotations: an existence in an untamed state; abandonment by one's parents; being raised and suckled by wolves, like Romulus and Remus; a creature, half-animal, half-human, that represents both danger and power, and so forth.

Farrell's experiences as a punk added to his feelings of alienation and rebellion and sensitized him to the experiences of others who were marginalized, outcast, and dispossessed. He now asserts that the years he spent as a "street punk" built character and gave him the backbone that contributed to his later success as an artist. The lyrics of his songs, which often provide an honest and unflinching look at tragedy and the seamy side of urban life, reflect his own firsthand encounters with suicide, drug addiction, prostitution, and religious fanaticism. This gritty approach to life and art is expressed in such songs as "Then She Did . . ." which is about his mother's suicide and an ex-lover who had died of a drug overdose, and "Jane Says," which is a melancholy ballad about junkies, pimps, and a friend who was a prostitute. Farrell stresses the importance of "living dangerously," "taking chances," and having a "fearless" approach to life that consists of pursuing one's visions and seeking as many diverse experiences as possible. As he stated it: "Whatever you want to do, you owe it to yourself to do it, because it will teach you something, number one, and you'll find the answer, man. You'll figure it out. Put your hand in the damn fire." He repeatedly emphasized the importance of individual freedom, rebelling against oppressive societal norms, celebrating one's emotions and passions, and seeking ecstatic moments. Like other romanticists, he also expressed a reverence for nature and valorized the idea of humanity in its "natural" or "primitive" state.

Farrell and Body Adornment

Farrell's past and his beliefs at the time I interviewed him contain hints of what motivated him to choose certain forms of body adornment. Disturbed by the commercialization of punk style, Farrell abandoned many of the original forms of punk adornment once they became popularized and mass-marketed. As he put it, "The first time I saw somebody with a mohawk in Beverly Hills, I grew mine out. I just said, 'Well, punk's over with.' But it's not over with, you just gotta work a little harder to be a punk these days. . . ." During our discussion of the commercialization of punk style, I mentioned that I recently had seen a woman with a mohawk driving a Mercedes. Farrell responded with disgust, "But now let's see her put a fuckin' ring through her nose, or fuckin' sit there while somebody takes a razor blade and slices her skin! Or fuckin' not wash her hair for a

29

month or two. . . ." The permanent forms of body alteration embraced by Farrell were chosen specifically to distinguish himself from poseurs and weekend punks who had adopted the more accessible and transitory forms of punk style promoted by the fashion industry.

As a punk, Farrell at one time had a mohawk, later growing a braid to express his interest in Native American cultures. At the end of the braid he attached a bell. This style eventually evolved into dreadlocks—long, plaited strands of hair which extended halfway down his back (plate 34). Usually associated with Rastafarians, the dreadlocks style was chosen by Farrell because of its oppositional connotations and also because he found it an aesthetically pleasing look. Like Rastafarians, who, through their clothing, hair, and other forms of adornment, articulate their desire for the overthrow of "Babylon," Farrell regarded his dreadlocks as a symbol of defiance that proclaimed his dissatisfaction with the dominant society.

Creating dreadlocks requires that the hair be grown to a suitable length, and then, as Farrell explained, "not washed for a couple of weeks," until it becomes tangled and matted. He noted that even after the desired effect had been achieved, his hair could not be washed on a regular basis. The disheveled, "unclean" appearance of dreadlocks (an explicit transgression of dominant ideas about hygiene) and the degree of commitment they entail (a commitment that weekend punks would not undertake) were additional reasons for his choice of this hairstyle. Dreadlocks also suggest living in a "wild" and "natural" state, an ideal that Farrell often celebrated.

In addition to wearing dreadlocks, Farrell also attached assorted objects to his hair, such as a crystal, an Apache leather strap, a one-hundred-year-old bell from the belt of a gypsy belly dancer, and pieces of silver wire salvaged from a junk yard. He stated that he wore the Apache leather strap in order to express an identification with Native American cultures, which he regarded as spiritually superior to Western societies. The crystal and the gypsy bell were given to him by friends and were worn for their unique and antique qualities (plate 35).

Farrell also had two piercings in each ear, and he used assorted types of ear ornamentation, such as rings, studs, and clips (plate 36). Although he had initially considered his ear piercings and ornaments to be a means of identifying with punk, he now stated that multiple earrings among men were no longer shocking or necessarily associated with punk. Nonetheless, he continued to use ear ornaments because he found them aesthetically pleasing. He occasionally hung from one ear the dried tail of a rattlesnake—an

object that he said is a Navaho talisman of ritual power and "male potency."

Farrell's decision to have the design of a praying mantis tattooed on his upper right arm had to do both with aesthetics and with the magico-religious connotations evoked by this image (plate 37). He found the unusual appearance and strangely human mannerisms of the mantis compelling, and he was intrigued by the folklore about its warrior-like traits and spiritual powers: "In India, the praying mantis is a prophetic insect and worshipped. . . . One thing that attracted me was its strength—and its approach to death. The female mantis will protect her egg case against a human being—she'll actually try to fight back. I think it is an amazing and beautiful insect." For Farrell, his tattoo functions as a personalized totemic emblem that symbolizes the attributes that he admires and embraces—fierce courage, a savage survival instinct, and a prophetic spirituality.

The wearing of ornaments in the nose is a popular form of facial adornment in many non-Western cultures, but it has been a relatively rare practice in Western societies until recently. Farrell was motivated to have his nasal septum pierced and to hang a gold ring from his nose both for shock value and for aesthetic reasons: "One day, I was looking at *National Geographic* pictures of people with rings in their noses, and I really thought they were beautiful. So I took an earring, and I put it into my nose, and I said, 'God, you know, I really like that.' I really do think it's attractive—I'm not joking—it balances out my face" (plate 36). Farrell stated that his decision to have his septum pierced represented a certain degree of commitment, or a psychological "breakthrough" in terms of his attitudes toward his body, its adornment, and his relationship to mainstream society. After he had his nose pierced, he felt he had reached a point where "there could be no turning back . . . this permanently sets me apart from the mainstream; once I did it I felt that it put me over the edge, so to speak. . . ." The ring in Farrell's nose is not only a mark of his marginality and a source of aesthetic pleasure but further proclaims his identification with tribalistic cultures and expresses his interest in cultural contrasts: "I wanted to show cultures overlapping and in doing that show how preposterous people are in holding tight to their beliefs . . . to show that nothing is set and nothing is right. . . ."

The element of personal trauma, ordeal, and pain involved in this form of adornment also contributed to its meaning for Farrell. Shortly after his nose was pierced the first time, the ring fell out, and his nose had to be pierced again a month later. During this second piercing, the needle broke, necessitating a third piercing on

the same day, all of which was extremely painful. His experiences of enduring pain are significant here, somewhat resembling the ordeals in traditional rites of passage in which the participant's courage is demonstrated and commitment to a new identity is proven.

Farrell has endured another type of pain as a result of his nose piercing—the frequent negative responses that the sight of his nose ring evokes from others. He said that on several occasions he has been threatened, harassed, or physically beaten for wearing a ring in his nose: "Last year some drunk saw that I had a ring in my nose—he comes running up to my car, him and his friend—and starts pounding on the windshield, screamin', 'You're a freak!! Look at you!! You got a ring in your nose!! Freak!!!', so I flipped him off, and the guy opens my car door and whips out a blade and goes to stab me. He just missed me. I gassed it, and he fuckin' stabbed the car door. He didn't even care." When I asked if experiences like that ever made him question the types of body adornment he had chosen, he firmly responded, "No, it made me want to do it more. . . . It made me want to be more extreme . . . that's what makes me feel good about myself. It makes me feel like I'm standing up for freedom." Farrell repeatedly asserted that his body adornment is fundamental for his psychological survival, at one point stating

emphatically, "If I couldn't do this, if I couldn't express myself in this way, I'd kill myself. I feel I have to do this kind of thing, really. . . ."

After his septum piercing, Farrell decided to have his chest scarred in order to provide himself with a personal rite of passage and to permanently mark his separation from the dominant society. Until recently, scarification was practiced primarily among dark-skinned peoples to indicate social status, protect against disease, and embellish the body. Inspired and fascinated by non-Western scarification practices, Farrell chose to be scarred without the use of an anesthetic, flatly stating, "It's a rite of manhood. I figured it was about time I became a man" (plate 38). He claimed that the endurance of pain and the permanent nature of the scars were important factors in his decision to alter his body in this way. His statements about his thoughts before and during the scarification event indicate its intensity and significance: "I was scared shitless, to tell you the truth, beforehand. . . . As soon as the first incision came in, man, I fuckin' winced. . . . It was like this [he pretends to be holding a razor blade and makes short, vertical slices in the air with his hand] chit, chit, chit, chit, chit. . . . I just took it—after a while I just took the pain. And it wasn't that bad of a pain. I mean, I've had pain. It was painful, but, you know, it's painful get-

ting yelled at from a car, too [he shrugs and laughs]. I'm used to it. . . ." His comments about his feelings afterward are revealing as well: "I thought to myself, 'If you can do that, you can do anything you want, and there's the proof.' They're a reminder to me to get up off my ass." In discussing the permanent nature of his scars and the possibility that he might later regret his decision to be scarred, he stated, "No, these are my signs; I'm only going to do more of this type of thing as I get older and become more of an outsider. . . . If anything, I'll either do something really radical and extreme, and chances are a lot of people will know about it, or I'll just die. . . . My stance is just getting more and more like, 'God damn it, I'm getting madder and madder and I'm just looking weirder and weirder!'"

In a society in which meaningful initiation rites have become increasingly rare, Farrell constructed his own rituals, based loosely on practices associated with tribalistic societies, which marked changes in his self-identity. As in traditional rites of passage, the experiences of pain and ordeal are as important as the actual body decoration that symbolizes a change in one's status. Unlike traditional initiation rites, however, the trials that Farrell has endured are not culturally sanctioned nor do they integrate him into a larger community. Privatized and entirely individualistic,

these rituals represent his willful embracing of an outsider status. His scars in particular, as permanent signs of defiance, symbolize both his estrangement from mainstream society and a triumph over dominant values and lifestyles that he finds oppressive (plate 39). The temporary forms of body adornment embraced by most members of Western societies to declare their interests and social identities are insufficient for Farrell, who is compelled by his life experiences, worldview, and sense of aesthetics to permanently transform his body in symbolically powerful ways that oppose Western ideas of adornment, beauty, and the integrity of the body.

Much of Farrell's adornment creates a tension between stereotyped notions of the "primitive" and "barbaric" and that which is believed to be "civilized" and "cultured." Farrell claimed that one of the principal reasons for the forms of body decoration he has chosen is to expose the arbitrary nature of ideas about physical appearance and cultural differences, "to show people that these distinctions that we make are all just a joke. . . . I would like to see everybody different from each other, and still enjoying 'the view'—you know what I mean? And not feeling at all harmed by it, but feeling entertained by it." Yet he also regarded his body adornment as directly confrontational, stating, "It's a

way of letting people know that maybe everything is not 'okay.' People see me and maybe it disturbs them, maybe it makes them think . . . maybe it shocks them into thinking." By adopting forms of adornment associated with non-Western societies, Farrell has extended the shock aesthetic of punk in new directions, visually assaulting the world of conventional appearances and the assumptions that underlie them.

Inspired by his interest in and romanticizing of tribalistic societies acquired from *National Geographic* magazines and the lore of popular culture, Farrell has constructed a style of body adornment that expresses his own personal mythology. The forms of adornment that he has chosen, he feels, are essential for his psychological and emotional survival and crucial for the maintenance of his individuality. While detractors of punk and neo-tribal body art have claimed that the behavior of the individuals involved is deviant, pathological, or self-destructive, for Farrell and others like him, the permanent alteration of the body is a deeply meaningful, transformative act. This self-fashioning impulse leads to an individualizing of the body and seems directly related to the struggle to create a sense of identity in a society felt to be dehumanizing, alienating, and characterized by increasing conformity. For Farrell, his individuality, personal beliefs, sense of aesthetics, and oppositional stance must be articulated through the body and tangibly inscribed on his flesh.

Neo-Tribal Body Art

When Perry Farrell pierced his nose and scarred his chest in 1985, such forms of body modification were relatively rare among youth in American society. Over the past decade, however, unconventional piercing and tattooing as well as practices such as scarification, branding, burning, and cutting have become increasingly pervasive. The recent profusion of magazines such as *Piercing Fans International Quarterly, Body Art, Skin Art, Body Play, Tattootime, Skin and Ink, Tattoo World, Tattoos for Men,* and *Tattoos for Women,* among others, attests to the current fascination with body alteration. Supermodels now sport navel rings at fashion shows because they are "pretty" and "fun," and temporary stick-on tattoos and clip-on rings for the nose, navel, and lip (dubbed "mall rings") are now available at shopping malls (Menkes 1993:1). Despite the growing popularity of such forms of body modification and their partial co-optation by the fashion industry, scarring one's body or piercing one's nose, lip, eyebrow, navel, tongue, nipples or genitalia are still symbolically charged acts that have retained the capacity to disturb or horrify (plates 23, 40, 42, 43). Even getting a tattoo, because of the pain involved and the permanence of the design, transgresses

conventional ideas about adornment, explicitly violating the biblical proscription against cutting and marking the body. (Leviticus 19:28 says, "You shall not make any cuttings in your flesh . . . or tattoo any marks upon you.")

This interest in permanent body adornment is often referred to as "modern primitivism," a label inspired by the book *Modern Primitives* (Vale and Juno 1989). Credited with popularizing neo-tribal adornment, this volume consists of a compilation of photographs and interviews with people in Western societies who have adopted non-Western and tribal forms of permanent body modification, such as tattooing, piercing, and scarification. The term "modern primitive," according to one of the pioneers of the movement, Fakir Musafar, is used to refer to "a non-tribal person who responds to primal urges" by altering the body through ancient and usually non-Western practices (Vale and Juno 1989:13-14).

While this phenomenon has been condemned by some as psychopathological and denounced by others as a form of self-mutilation masquerading as subcultural style, the individuals who engage in such practices frequently refer to the spiritual, erotic, social, and aesthetic rewards to be gained from permanent body modification. Although motivations vary considerably, many give reasons that are similar to those articulated by Perry Farrell in 1985. They speak of body alterations as being rites of passage and expressions of estrangement from mainstream society, as well as being a means of gaining a sense of control over their bodies or enhancing sexual pleasure (plates 40, 41, 42, 44). Like Farrell, many state that the body-modifying impulse ultimately involves the desire to embellish oneself in aesthetically pleasing ways and to "carve" an individual identity in a culture that encourages conformity and discourages physical differences that deviate from dominant ideals about the body.

While the initial interest in neo-tribalism developed independently of the punk subculture, the punk preoccupation with piercing and tattooing has definitely contributed to the fascination with such forms of body alteration today. The connection between punk and neo-tribalism is explicitly illustrated by the fact that the editors of the book *Modern Primitives,* V. Vale and Andrea Juno, also published the important punk fanzine, *Search and Destroy,* in 1977-1978. Punk adornment, with its elaborate hairstyles, colorful clothing, facial painting, tattooing, and multiple piercings often suggested non-Western forms of body art and a tribal aesthetic. However, in contrast to the "modern primitive" emphasis on the psychological, sexual, or spiritual benefits of body alteration, the initial punks often engaged in such practices to express their sense of disillusionment, despair, and futility. Unlike many neo-tribalists who now

have their bodies modified by professionals in body piercing and tattoo studios, punks often did their own piercings and tattoos, skewering themselves with safety pins and debris, lacerating their flesh with crude implements, and marking their skin with images of death. Revelling in the pleasures of self-destruction, the early punks embodied the idea of negation and enacted, in the flesh, their sense of decay and apocalypse.

Neo-tribalism, on the other hand, tends to emphasize the transformative rather than the destructive aspects of body modification, often expressing a yearning for idealized ways of life imagined to be more fulfilling emotionally, spiritually, and sexually. This utopian urge is noted by the editors of *Modern Primitives:* "What is implied by the revival of 'modern primitive' activities is the desire for, and the dream of, *a more ideal society.* Amidst an almost universal feeling of powerlessness to 'change the world,' individuals are changing what they *do* have power over: *their own bodies. . . .*" (Vale and Juno 1989:4). Pierced, scarred, and tattooed, the bodies of neo-tribalists become sites of symbolic control inscribed with primordial power, at a time in which the human body appears increasingly vulnerable, assaulted by the threat of AIDS, environmental destruction, nuclear holocaust, genetic manipulations, the invasive technologies of the medical industry, chemical pollutants, escalating violence and murder, and other forms of bodily

exploitation, torment, and annihilation. Through simulations of primitivism, the body, the last refuge of authenticity and self-identity, is redeemed by a pastiche of ancient tattoos and fortified by tribal piercings made of titanium and stainless steel.

In 1985, Perry Farrell exemplified the connection between punk and neo-tribalism, embracing the ethos of punk but also valorizing "primitive" aesthetics and rituals. Motivated in part by a sense of loss and a disillusionment with the values and "progress" of Western society, Farrell adopted neo-tribal adornment as a means to display his feelings of estrangement, to shock, and to express an identification with non-Western cultures. Through painful and private rites of initiation, he attempted to express his sense of individuality by transforming his body into a subversive work of art, sanctified by blood and marks. For Farrell, and for many other punks and neo-tribalists, the body is a site of symbolic resistance, a source of personal empowerment, and the basis for the creation of a sense of self-identity. By adorning and altering their bodies in symbolically powerful ways, both punks and neo-tribalists may proclaim their discontent, challenge dominant ideologies, and ultimately express the yearning for a more meaningful existence.

References

Allen, Dave. 1994. "Perry Farrell, Lollapalooza, and I." *Raygun* (June-July): 34–39, 42, 43.

Arnold, Gina. 1993. *Route 666: On the Road to Nirvana*. New York: St. Martin's Press.

Belsito, Peter, and Bob Davis. 1983. *Hardcore California: A History of Punk and New Wave*. Berkeley: Last Gasp.

Brake, Michael. 1985. *Comparative Youth Culture: The Sociology of Youth Culture and Youth Subcultures in America, Britain, and Canada*. London: Routledge & Kegan Paul.

Frith, Simon, and Howard Horne. 1987. *Art into Pop*. London and New York: Methuen.

Gold, Jonathan. 1994. "Lord of the Rings." *Spin* 10, no. 5 (August):42–46.

Hall, Stuart, and Tony Jefferson, eds. 1991 [1975]. *Resistence Through Rituals: Youth Subcultures in Post-War Britain*. London: Harper Collins.

Handelman, David. 1991. "Jane's Addiction." *Rolling Stone* 597 (7 February):68–71.

Hebdige, Dick. 1988. *Hiding in the Light: On Images and Things*. New York: Routledge.

———. 1979. *Subculture: The Meaning of Style*. London: Methuen.

Heiman, Andrea. 1994. "Way Out There." *Los Angeles Times* (14 January):E2.

Henry, Tricia. 1989. *Break All Rules!: Punk Rock and the Making of a Style*. Ann Arbor, MI: UMI Research Press.

Jones, Michael Owen. 1987. *Exploring Folk Art: Twenty Years of Thought on Craft, Work, and Aesthetics*. Ann Arbor, MI: UMI Research Press.

Laing, Dave. 1985. *One Chord Wonders: Power and Meaning in Punk Rock*. Milton Keynes and Philadelphia: Open University Press.

Leland, John. 1991. "Welcome to the Jungle." *Newsweek* (23 September):53–54.

McRobbie, Angela. 1991. *Feminism and Youth Culture*. Boston: Unwin Hyman.

Marcus, Greil. 1989. *Lipstick Traces: A Secret History of the Twentieth Century*. Cambridge, MA: Harvard University Press.

Menkes, Suzy. 1993. "Fetish or Fashion?" *New York Times*, Section 9 (21 November):1, 9.

Narváez, Peter. 1992. "Folkloristics, Cultural Studies and Popular Culture." *Canadian Folklore Canadien* 14, no. 1:15-30.

Nehring, Neil. 1993. *Flowers in the Dustbin: Culture, Anarchy, and Postwar England*. Ann Arbor: The University of Michigan Press.

Rubin, Arnold, ed. 1988. *Marks of Civilization: Artistic Transformations of the Human Body*. Los Angeles: Museum of Cultural History, University of California, Los Angeles.

Savage, Jon. 1991. *England's Dreaming: Anarchy, Sex Pistols, Punk Rock, and Beyond*. New York: St. Martin's Press.

Selzer, Michael. 1979. *Terrorist Chic: An Exploration of Violence in the Seventies*. New York: Hawthorn.

Taylor, Lori Elaine. 1993. "Riot Grrrls Convention 1992, Washington, D.C." *Ethnopop* 3, no. 1B (Winter):1–2.

Turner, Victor W. 1969. *The Ritual Process: Structure and Anti-Structure*. Chicago: Aldine.

Vale, V. and Andrea Juno, eds. 1989. *Modern Primitives: An Investigation of Contemporary Adornment and Ritual*. San Francisco: Re/Search Publications.

Young, Katharine, ed. 1993. *Bodylore*. Knoxville: The University of Tennessee Press.

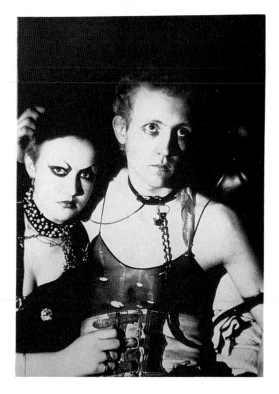

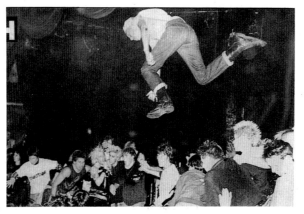

PLATE 1
Bound, chained, and decorated in debris, these British punks use body adornment to suggest enslavement and the idea of being "society's garbage," while at the same time endowing themselves with a martyr-like aura.

PLATE 2
A fan leaps from the rafters at a concert while other fans surround the band G.B.H. on stage (center of photo).

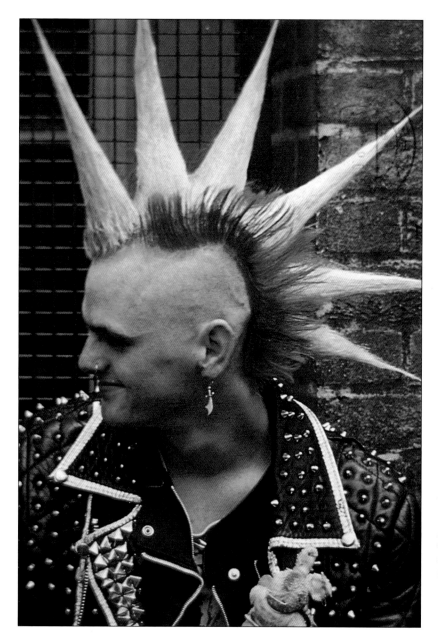

PLATE 3
A shock-haired punk with enormous bleached spikes, a nostril ring, a cutlass earring, and a studded leather jacket from which dangles a stuffed animal pierced with safety pins.

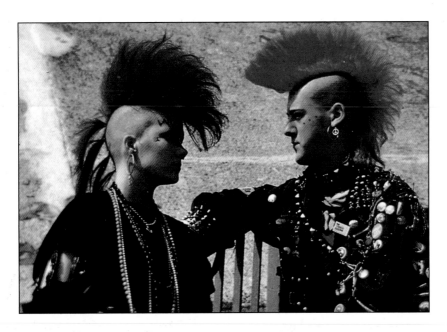

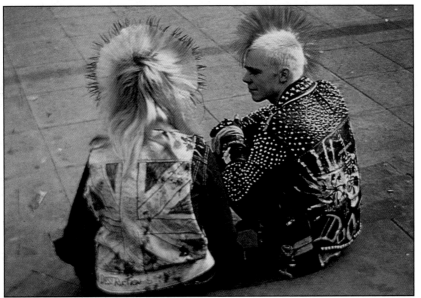

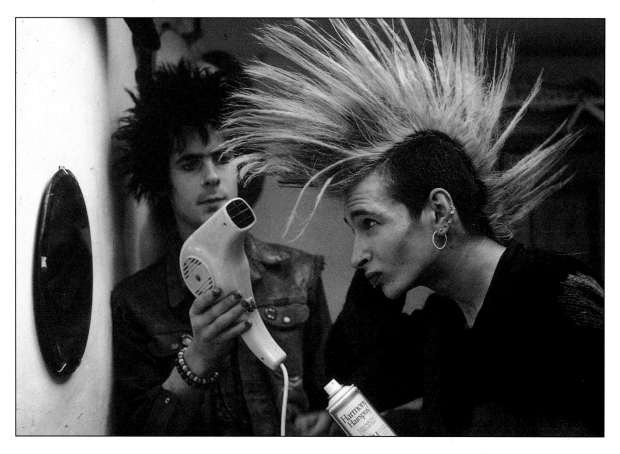

PLATE 6
A London punk perfects the form of his massive mohawk with assistance from a friend and a can of Harmony Hairspray ("Extra Hold for Difficult Hair").

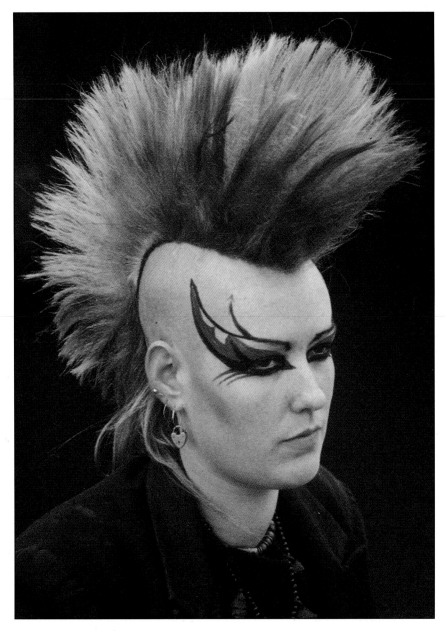

PLATE 7
A London woman with a turquoise mohawk, multiple ear piercings, and facial painting.

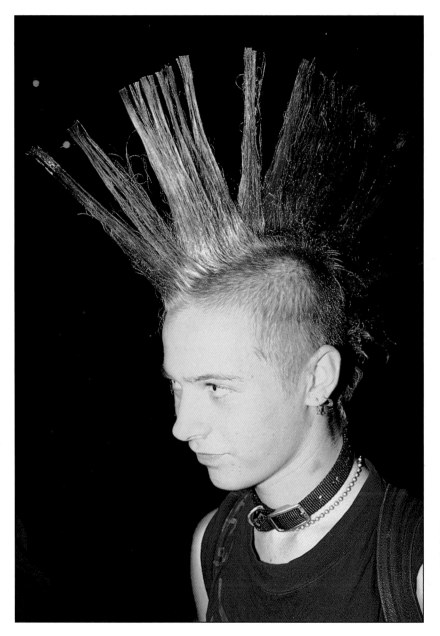

PLATE 8
A New York City punk with
an orange-red mohawk in
the East Village, 1994.

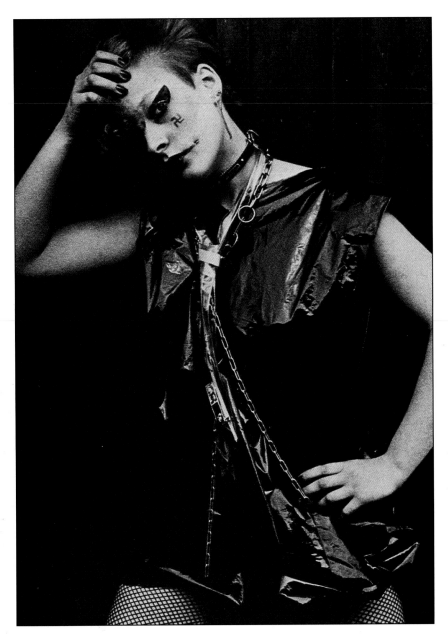

PLATE 9

The types of adornment depicted in this photo (a safety pin through the cheek, a swastika painted on the face, a leather collar, chains, fishnet stockings, and a "dress" made of a plastic garbage bag) exemplify the numerous taboos and offensive themes that early punks drew upon—mutilation, fascism, bondage, explicit sexuality, and self-degradation.

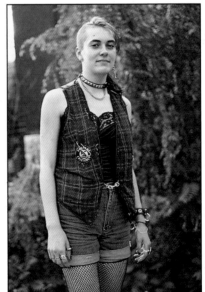

PLATE 10
A woman in the East Village of New York City in 1994 with cropped hair, boots, a nose ring, a lip ring, multiple finger rings, and assorted wrist bands and bracelets.

PLATE 11
A recent immigrant from Poland, now living on the streets of New York City, with a partially shaved head, dyed hair, studded collar, and fishnet stockings in the East Village, 1994.

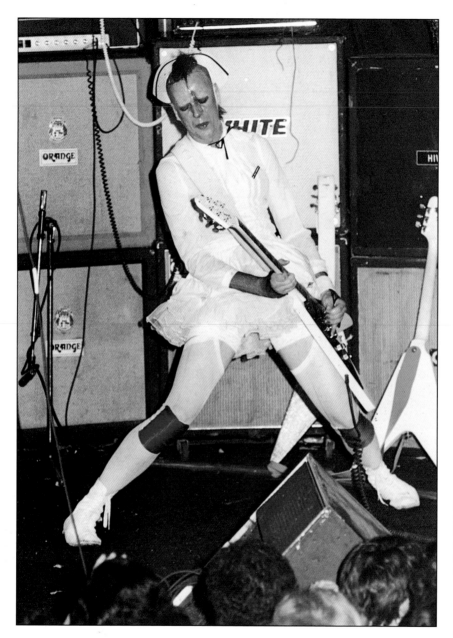

PLATE 12
Ritchie Sotts of the
Plasmatics with a mohawk,
eyeliner, a tu-tu, nylons, a
nurse's hat, and blood run-
ning down his forehead.

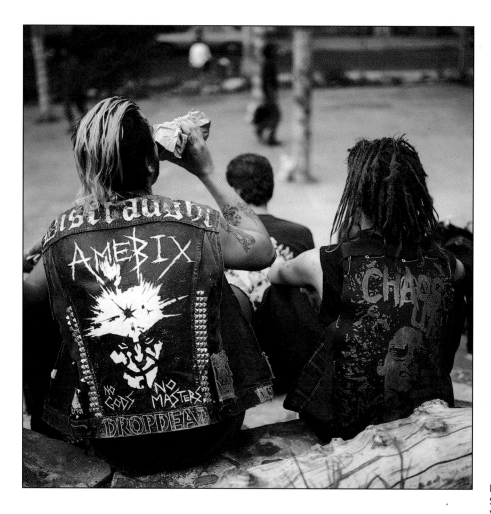

PLATE 13
Street punks in the East
Village of New York City in
August, 1994, wearing
sleeveless jackets painted
with the names of the politi-
cally oriented British bands
Amebix and Chaos UK.

47

P L A T E 1 4
A London punk wearing a
leather jacket with assorted
studs, multiple piercings in
one ear, and a nose stud.

48

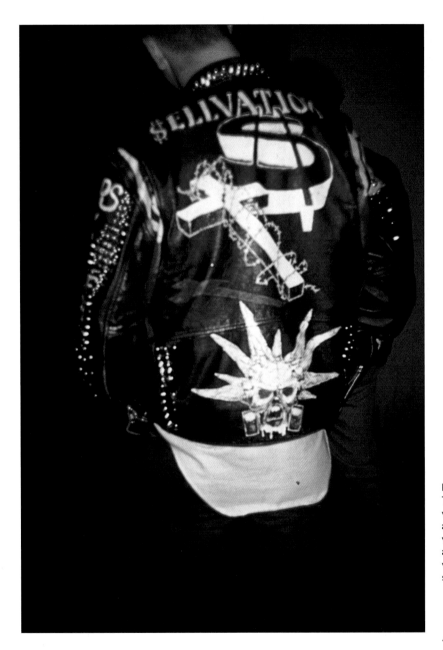

PLATE 15
The back of a leather jacket with a painting in acrylics of a cross entangled in barbed wire beneath a dollar sign and the word "Sellvation" with a spiked-haired punk skull on the waistband.

49

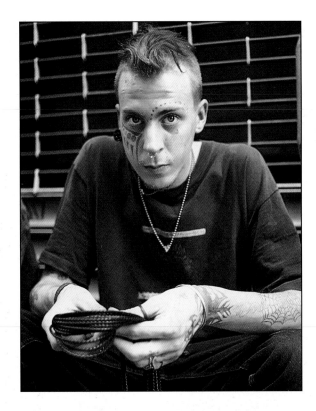

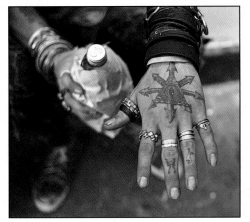

PLATE 16

While most punks had tattoos in conventional areas such as the bicep, forearm, or back, some chose to have tattoos placed on their foreheads, cheeks, necks, around the eyes, and on the sides of the head. Tattoos in such areas are difficult, and sometimes impossible, to remove. The tattoos on the face of this New York City street punk not only proclaim his commitment to punk, but permanently mark him as one who is separated from mainstream society.

PLATE 17

The tattooed and ornamented hand and wrist of a New York City punk.

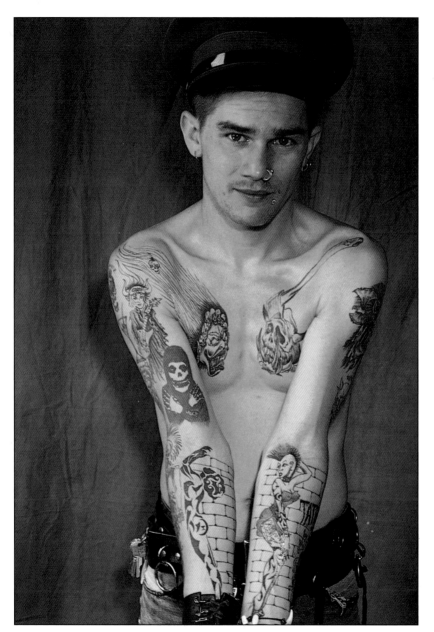

P L A T E 18

The tattooed arms of Richard Robinson (aka Natas Doom) illustrate the pastiche aesthetic popular among many punks. Images of demons and grinning skulls (including the logo of the band Misfits in red) are juxtaposed with a scantily clad, tattooed punk woman with a mohawk, a silhouette of a woman in black, and a martini garnished with an olive.

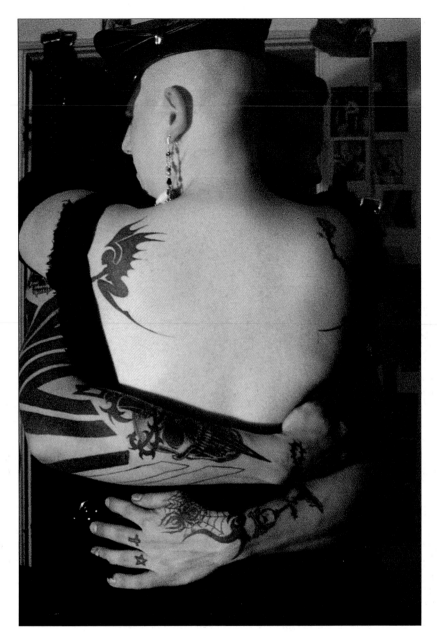

PLATE 19
A Los Angeles punk couple
with tattoos consisting of
assorted skull, bat, flower,
and neo-tribal designs.

52

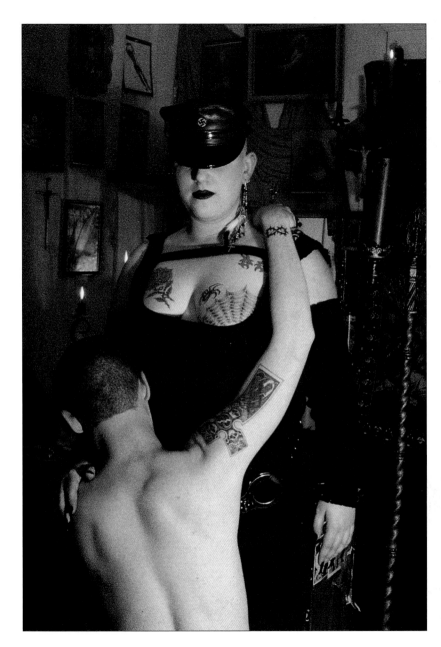

PLATE 20

While some punk women were tattooed in conventional areas, many had tattoos on their hips, breasts, and shoulders, as shown here. In addition to tattoos, the use of leather wear, militaristic uniforms, and sex shop accouterments depicted here reflects the punk preoccupation with "deviant" sexuality and the ideas of dominance and submission.

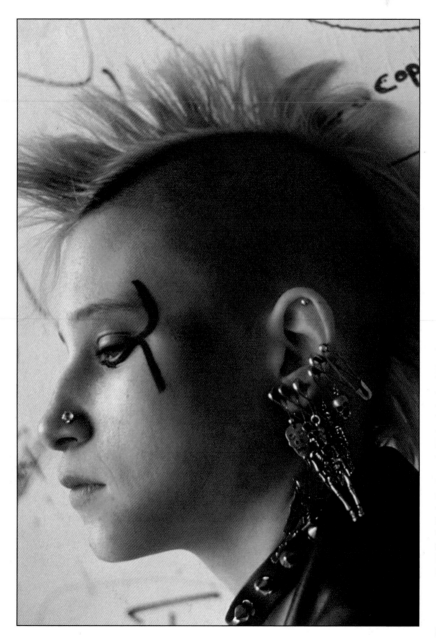

PLATE 21
The punk practice of multiple piercings and the diversity of commonplace and offensive objects used as earrings were disturbing transformations of this form of adornment, illustrated here by the use of numerous safety pins from which hang skeletons and a skull. Punk ear decoration ultimately contributed to the contemporary popularity of multiple ear piercings, a style of body art common in tribal cultures but relatively rare in Western societies until recently.

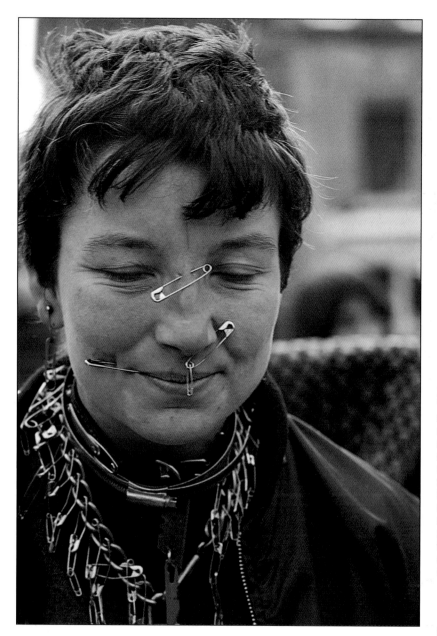

PLATE 22
The piercing of the face with safety pins was the most shocking aspect of punk style, communicating in a disturbingly visceral manner a complexity of meanings—mutilation, masochism, suffering, self-destruction. Here a necklace consisting of a chain and lock with safety pins and saw blades conveys further a sense of abuse and defilement by society's debris.

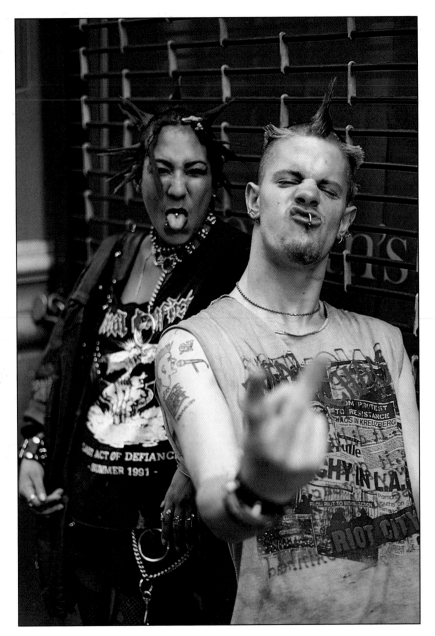

PLATE 23
A New York City couple in the East Village in 1994, adorned in classic punk style, saluting the camera in a characteristically punk fashion. Although some have claimed that punk adornment has been incorporated into mainstream society and is now less threatening, a lip ring, a metal bar in the tongue, and multiple safety pins in an ear still have the ability to shock and evoke distaste.

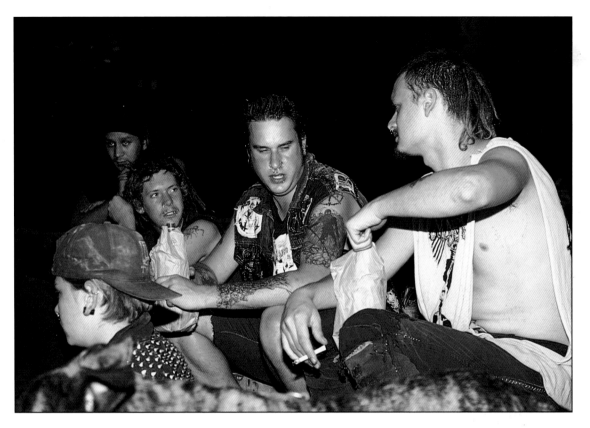

PLATE 24
Street punks with assorted
tattoos and facial piercings,
drinking beer and discussing
music and politics in the
East Village, New York City,
1994.

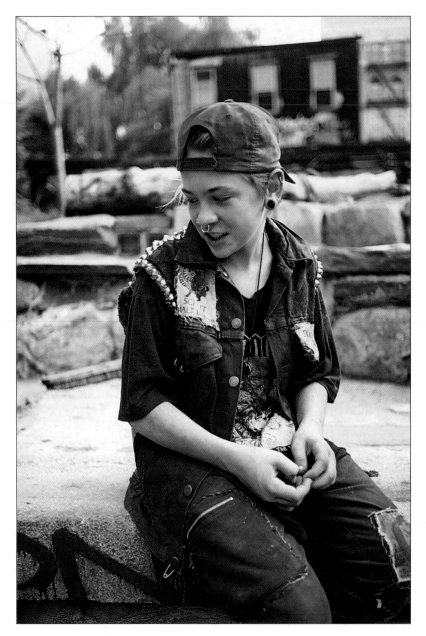

PLATE 25
A fourteen-year-old runaway punk with a nose ring and an ear plug who lives on the streets and survives by begging and squatting in the East Village, New York City, 1994.

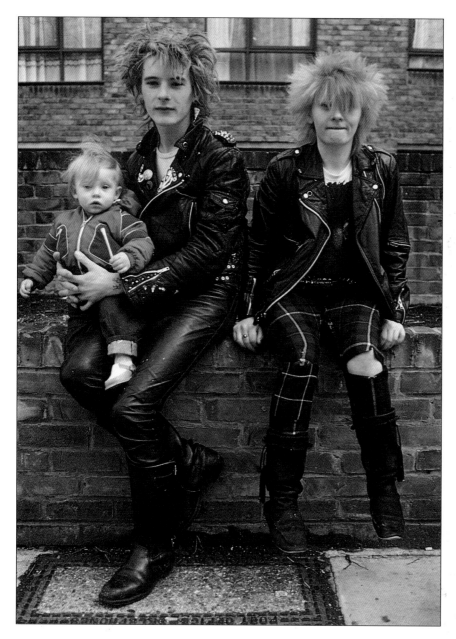

PLATE 26
A British couple with fluo-
rescent hair adorned in
black leather and tartan,
with their baby girl.

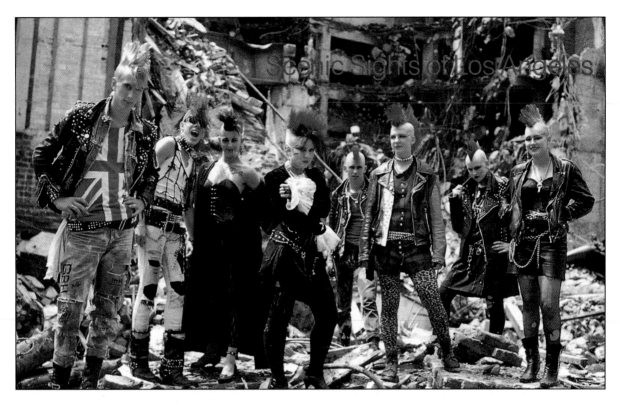

PLATE 27
A postcard depicting punks, entitled "Scenic Sights of Los Angeles." Although this card accurately illustrates some of the more spectacular forms of punk adornment, its contrived nature and ironic title ultimately render punk style less threatening.

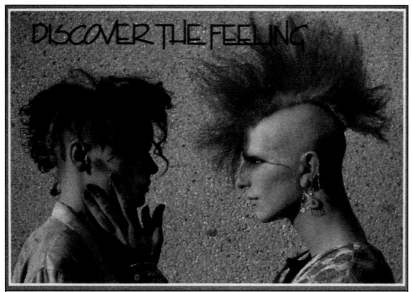

DISCOVER THE FEELING

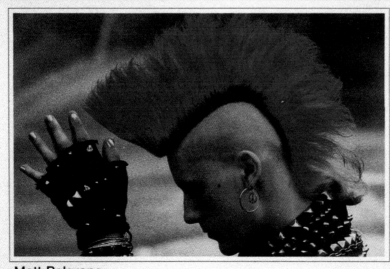

Matt Belgrano.

PLATE 28

These postcard depictions of punks offer a surface celebration of punk aesthetic, completely dislodged from its ethos. Even if the individuals depicted here were "hardcore" punks, these representations transform them into entertaining images to be sent to family and friends for amusement.

Finding the right role model is far too important to be left to chance.

THE GUIDANCE CLUB FOR TEENS™

PLATE 29
This cover article for the "Fashion" section in the *Los Angeles Times* (January 14, 1994) on "neo-punk" style is entitled "Way Out There," and its subtitle reads: "Punk hair is back all right, and it's as outrageous—and colorful—as ever. But this time around, wearers say it's not a rebellious look—just a cool one." This revival of early punk adornment has become increasingly popular among teenagers in middle school. The fact that some models sported punk hairdos on the runways of recent fashion shows also has contributed to the appeal of punk aesthetics divorced from punk ethos.

PLATE 30
Images of punk folk devils are still used to depict the antithesis of a positive role model for youth, as in this back cover of a promotional catalog published in 1994 by the Guidance Club for Teens, a company that markets videos focusing on the concerns and problems experienced by teenagers.

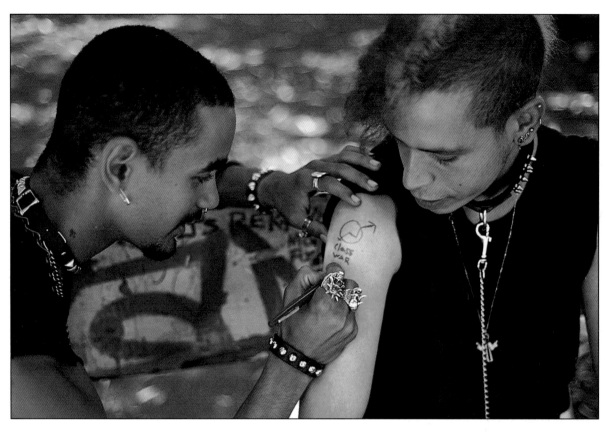

PLATE 31
A New York City punk gives
a friend a felt pen tattoo of
the slogan "Class War"
(taken from the title of a
song by the punk band the
Dils) in the East Village in
1994.

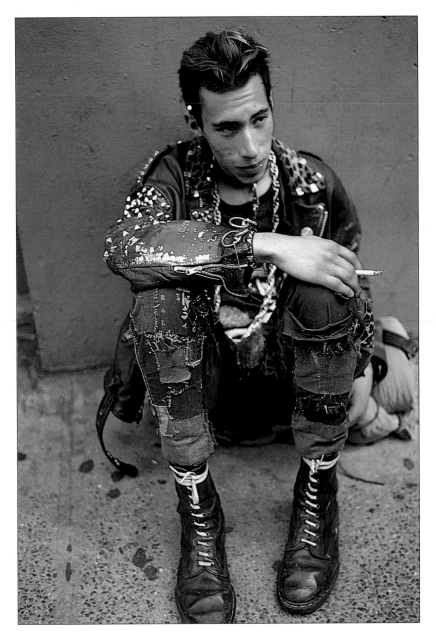

PLATE 32
A street punk in patched
pants, black boots, chains,
and a leather jacket with a
leopard skin collar in New
York City, 1994.

64

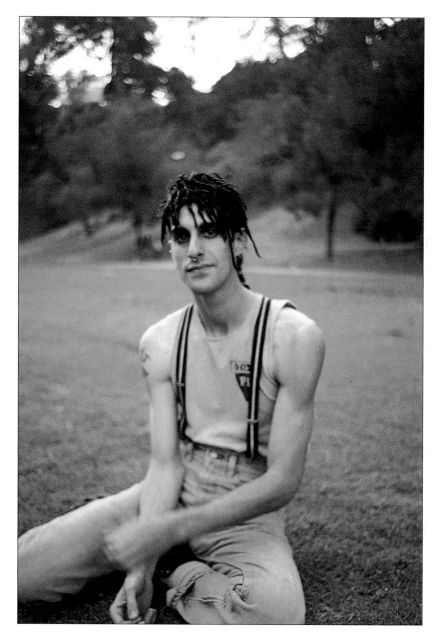

PLATE 33
Perry Farrell in Griffith Park,
November, 1985.

65

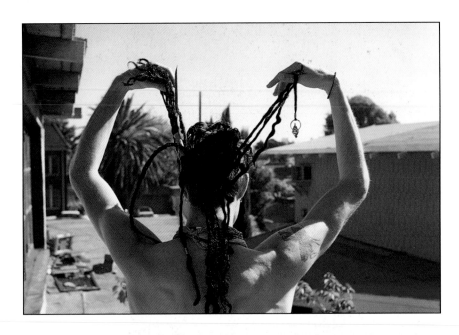

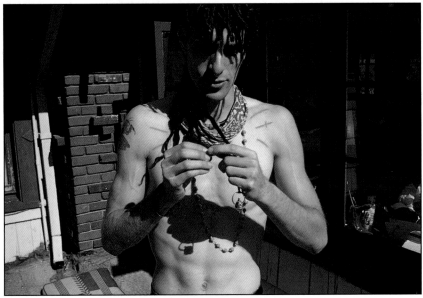

PLATE 34
Farrell displays his dread-locks.

PLATE 35
Farrell examines one of the objects that he has placed in his hair as he explains its significance.

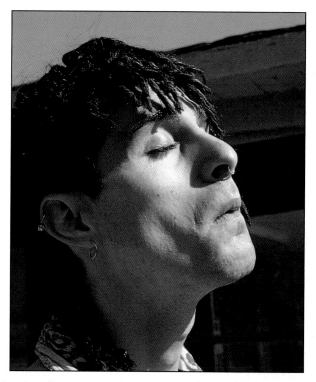

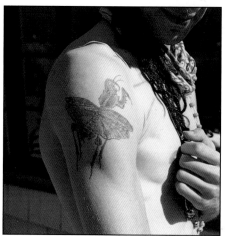

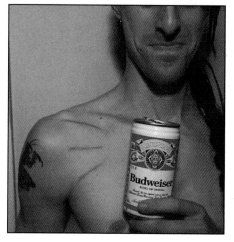

PLATE 36
Farrell flaunts his nose ring
and ear ornaments.

PLATE 37
Farrell's ornately designed
mantis tattoo.

PLATE 38
Farrell displays the scars on
the right side of his chest.

67

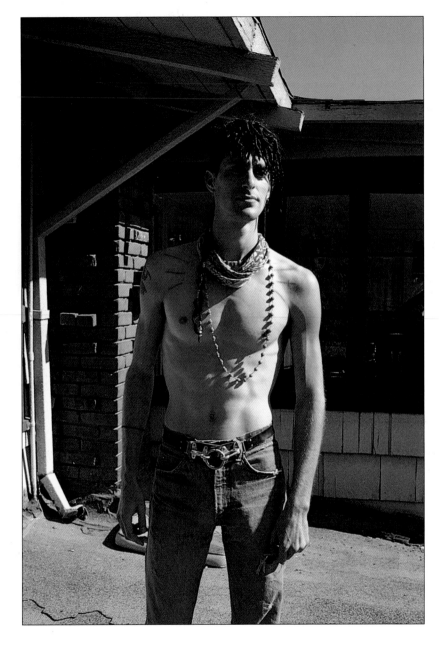

PLATE 39
Farrell's scars and other
forms of adornment.

68

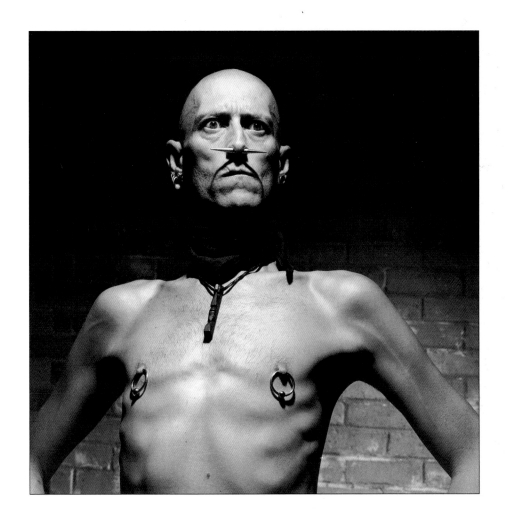

PLATE 40
A man from London with
multiple ear piercings, a bar
through his nasal septum,
and pierced nipples.

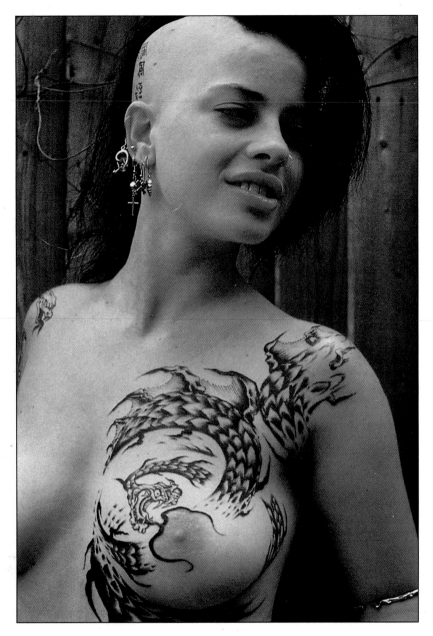

PLATE 41
Alexxx, from Nyack, New York, has a nostril ring, multiple piercings in both ears, and multiple tattoos.

70

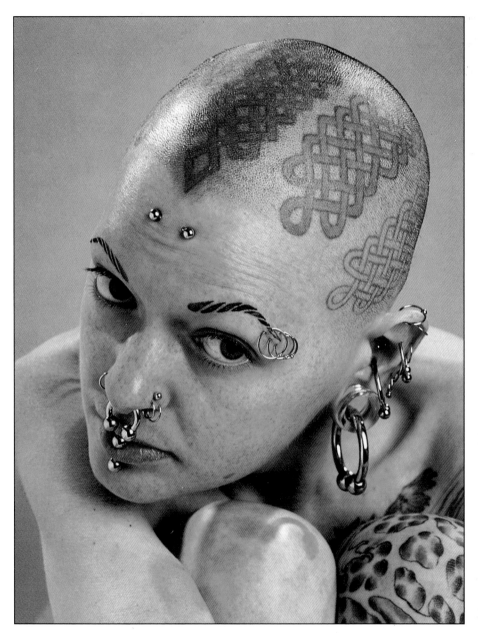

PLATE 42
Jen, with multiple facial piercings and tattoos. Unlike punks who often embrace body piercing and tattooing for shock effect and the aesthetic of "self-laceration," those who practice neo-tribal tattooing and body piercing tend to emphasize the ritual, erotic, and "self-beautifying" aspects of such forms of adornment. Head tattoo by Bill Salmon; leg tattoo by Tom Beaselley.

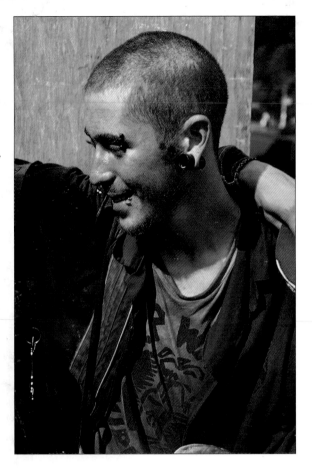

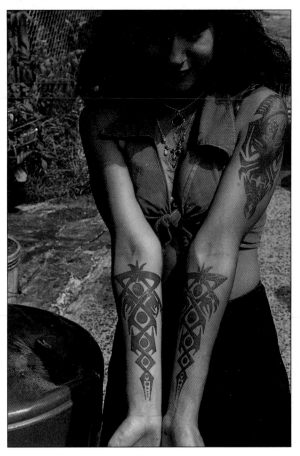

PLATE 43
A street punk with a large
plug in his ear and piercings
in his lip, nose, and eyebrow,
in the East Village, New York
City, 1994.

PLATE 44
A woman in New York City
with tribal designs tattooed
on her forearms and else-
where.